IMAGES
of America

FAIR LAWN

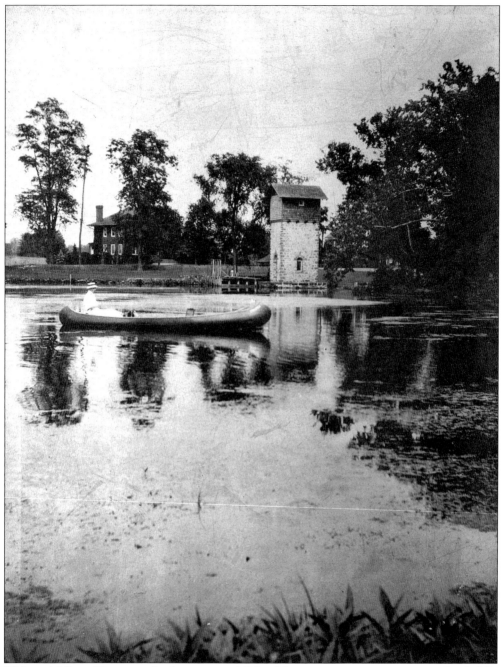

Walter Adelbert Fleming, who later married Edna Hopper, is rowing a canoe on the Saddle River at Easton's Mill in 1914.

IMAGES
of America

FAIR LAWN

Elaine B. Winshell and Jane Lyle Diepeveen

ARCADIA
PUBLISHING

Published by Arcadia Publishing
Charleston SC, Chicago IL, Portsmouth NH, San Francisco CA

Printed in the United States of America

Library of Congress Catalog Card Number: 2001091554

For all general information contact Arcadia Publishing at:
Telephone 843-853-2070
Fax 843-853-0044
E-mail sales@arcadiapublishing.com
For customer service and orders:
Toll-Free 1-888-313-2665

Visit us on the Internet at www.arcadiapublishing.com

CONTENTS

ACKNOWLEDGMENTS

Nearly every milestone in the life of Fair Lawn was celebrated, photographed, and written about. These records have been a valuable resource in putting together this collection. Committees of residents supported by business and civic organizations produced anniversary journals for the 25th, 50th, and 75th anniversary celebrations. We relied heavily on their information. The recent 75th anniversary celebration committee, headed by John Cosgrove, produced a journal that was immortalized by a technology not available to earlier journals—namely, the CD-ROM. Many of the images in this book were taken from that CD-ROM. The Fair Lawn League of Women Voters and the Fair Lawn Department of Recreation also provided us with images as well as information.

A 1960 privately printed volume—*From Slooterdam to Fair Lawn*, by Robert Rogers—was a source of much of the information about the early houses and history of the area that included Fair Lawn. It was also the source of photographs that could not be found elsewhere. We are grateful to Rogers for all his research. Fair Lawn's *Sixtieth Supplement A* of the *Shopper* newspapers (published on October 17, 1984) was also a source of historical information.

Louise Orlando, manager of the Radburn Association, generously allowed us to use the association's photographs of Radburn. Rebecca Auerbach let us select old postcards from her extensive collection. Individuals responded to our requests and supplied us with several interesting and historic pictures. For these we thank Robert Gordon, Samuel Wolosin, Vincent Sadowski, Marge Stager, Robert Lockhart, Lois Horowitz, Corinne Fleming, Donald Landzettel, June Schwartz, and Goldie Pressman.

David Utidjian, physics assistant at Ramapo College of New Jersey, came to our rescue by scanning images that could not be shipped out of town. He burned a CD-ROM with these images, thus compensating for our technological shortcomings.

INTRODUCTION

The earliest settlers of the area now known as Fair Lawn were members of the Lenni Lenape tribe, who arrived about 12,000 years ago. These peaceful hunter-gatherers built the V-shaped fish trap in the Passaic River, which the Dutch called a *slooterdam*. This landmark lent its name to the area until 1791. These indigenous people gradually sold their lands to the Dutch and English settlers and moved into Pennsylvania.

The East Jersey Proprietors, who controlled the land, divided the area south of what is now Fair Lawn Avenue into five large lots, extending from the Saddle to the Passaic Rivers. The first farmer in what is now Fair Lawn, Daniel Danielson, leased the Slooterdam Patent in 1708. Peter Garretson bought part of that patent north to the fish trap c. 1719 and built a house on the southern part of the property near Garretson's Lane. The oldest parts of the sandstone house still standing were built between 1708 and 1730.

Dutch farmers settled in the area in the mid-to-late 1700s; several of these mostly sandstone farmsteads are still standing. A hamlet, the only one, developed around the Red Mill, which was built in 1745 as a gristmill at the junction of two coach roads, one being Paramus Road.

During the Revolution, the Tories, who would hide in "Great Thicket" along Swamp (Saddle River) Road, conducted raids on the Dutch farms. "Light Horse" Harry Lee, known for daring excursions against the British, stayed at the Alyea-Outwater house on Wagaraw Road for a short time while his contingent was guarding Lafayette's troops encamped in today's Hawthorne. Several Slooterdam residents served in the Revolutionary War, including Andrew Hopper, who was general of the Bergen Militia.

During the 1800s, sale or inheritance divided many larger farms. By 1861, there were three new roads to serve the new farms. Small Lots Road (Fair Lawn Avenue) served the nine "small lots" established earlier. Prospect Street, at the top of the Small Lots hill, connected to the north with Swamp Road. Cherry Lane (Lincoln Avenue), built in 1825, led from Paterson eastward to Glen Rock. In 1861, there were about 80 houses, mostly farmsteads, and the Fair Lawn area was known as Small Lots. As late as 1876, Small Lots was mainly agricultural and part of Saddle River Township.

The only new road was Berdan Avenue, on which five Berdan families had farms. In the mid-19th century, homes were built in the Victorian styles. The grandest of these was a mansion built by David Depeyster Acker on one of the highest points in town with a lawn sloping down to Small Lots Road. He called his estate Fair Lawn.

At the end of the 19th century, land near the bridges over the Passaic River was subdivided for small homes. They were sold to the workers in the weaving and dying mills in Paterson and along Wagaraw and River Roads in what is now Fair Lawn. Some of the homes and a foundry from that period are still standing. Construction of small homes continued through the early part of the 20th century. Most residential development occurred in three sections: the Flats (now Fair Lawn Center), in the River Road–Fair Lawn Avenue area; "Columbus" Heights, at Lincoln Avenue and Wagaraw Road; and Warren Point, east of the railroad and south of Broadway. The establishment of a post office, a railroad station, and a trolley to the Hudson River spurred development of this section.

In May 1923, a referendum to create five new schools in what are now Fair Lawn and Saddle Brook was held, but only one school in Saddle Brook and a new brick building to replace the wooden Warren Point School were approved. This angered Fair Lawn residents in other sections of town, who had only the old Washington School, while Columbia Heights children had to attend school in Hawthorne. A movement to secede from Saddle River Township was started. This was hotly debated, with some farmers fearing taxes would rise and other citizens complaining they were paying taxes but not getting schools. Fair Lawn residents petitioned the state to create enabling legislation to incorporate as a borough. At a special election in April 1924, the borough was voted into existence.

Fair Lawn's first governing body was organized in June 1924. The first school board was elected in 1925. In 1927, the Acker Estate was purchased for use as the borough hall.

Fair Lawn grew quickly. From 1925 to January 1929, the population grew from 1,800 to 4,500 people as families were attracted to new homes and schools. Because of the growth, a zoning ordinance was created to separate types of land use. The development of Radburn—the unique "Town for the Motor Age" with super blocks, cul-de-sacs, and interior parks separating vehicles from pedestrians—provided another growth spurt from 1929 until about 1933, when building was slowed by the Great Depression. The famous architect-planners Henry Wright and Clarence Stein designed Radburn. Although it never reached its planned size of 25,000 people, the elements of the plan have been copied all over the world.

Fair Lawn continued to grow in other sections. Between the 1940 census and sugar-rationing registration in 1941, the borough was the fastest growing community in the country, with population increasing from 9,000 to 13,000 in approximately one year.

World War II saw the departure of most of Fair Lawn's young men. The old Wagaraw Road factories were taken over by Wright Aeronautical, which made airplane engine parts, and a company that processed parachute material. Columbia Heights had an antiaircraft unit, and the edge of Radburn was a staging area for troops going overseas.

The population grew from 9,000 in 1940 to an estimated 37,000 by 1968. In 1950, the planning board (established in 1939) approved 20 subdivisions, some of considerable size. Local shopping areas were expanding. New schools and additions were constructed. The Fair Lawn Industrial Park, with factories in a parklike setting, was developed on one of the last borough farms in the 1950s and 1960s. The "Miracle Mile" brought many new workers to Fair Lawn. The borough was booming.

Fair Lawn has always been a volunteer town, starting with the fire companies and the council members operating the snowplow. Volunteers started the library, Memorial Pool, and the Helda Walsh Pool. In 1953, Fair Lawn received an All-America Cities award in recognition of the constructive action of the Citizens School Committee in securing new schools, and the Non-Partisan League for successfully campaigning to institute the nonpartisan municipal manager form of government.

The last of the farms yielded to development in the 1990s. Fair Lawn has a varied housing stock of homes, townhouses, and apartments. An increasingly heterogeneous mix of people lives in them. One of the borough's challenges in the new century will be integrating the latest wave of newcomers into the community.

One

EARLY SETTLERS

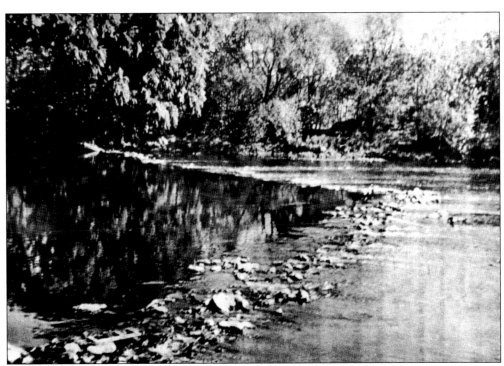

The Lenni Lenape Indians constructed this fish trap on the Passaic River. It is visible about 200 yards upstream of the current Fair Lawn Avenue Bridge when the water level is low. The Dutch called this type of trap a *slooterdam*, which is why Fair Lawn was known as Slooterdam until 1791.

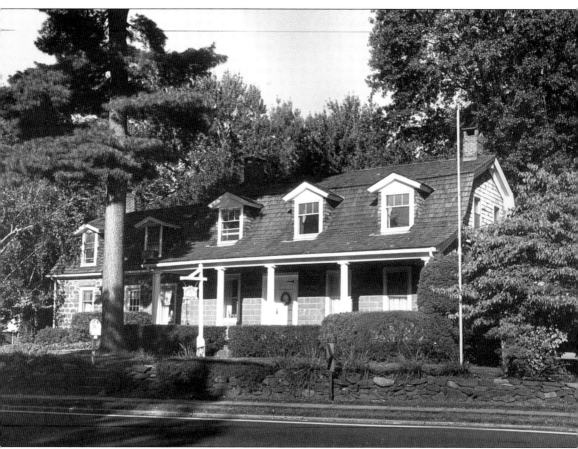

The Garretson-Brocker Homestead is the oldest house in Fair Lawn. It was built between 1708 and 1730, with newer portions added c. 1800. The gambrel roof, dormer windows, and porch were added in 1903. Several outbuildings—including a Dutch kitchen, a smokehouse, a pigpen, and a wagon house dating from the early 17th century—were built on the property. Peter Garretson purchased the land, which extended from the Passaic River to the Saddle River, in 1719. The deed was known as the Slooterdam Patent. Private and Bergen County funds were used to acquire the homestead, which is now known as the Garretson Forge and Farm. It is regularly open to the public and stages reenactments of early American life. The house was listed as the Peter Garretson House on the National Register of Historic Places in 1974.

Feenix Brocker was the last family member to live in the Garretson-Brocker House. He was married to Mary Garretson and, on her death, inherited the property.

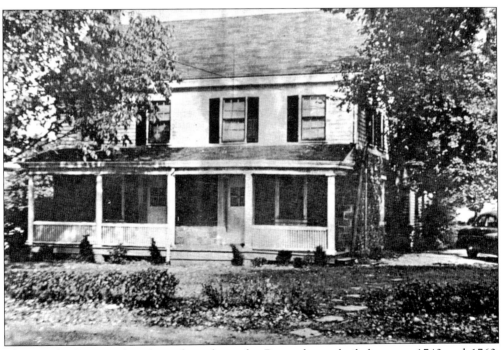

The Dutch House is thought to have been the Bogert house built between 1740 and 1760. Richard J. Berdan acquired it on April 16, 1808. Used as a tavern or restaurant since 1929, it is now owned and operated by the Drahouzal family as the Dutch House Tavern. The front porch was removed sometime in the past. This structure was listed as the Richard J. Berdan House on the National Register of Historic Places in 1983.

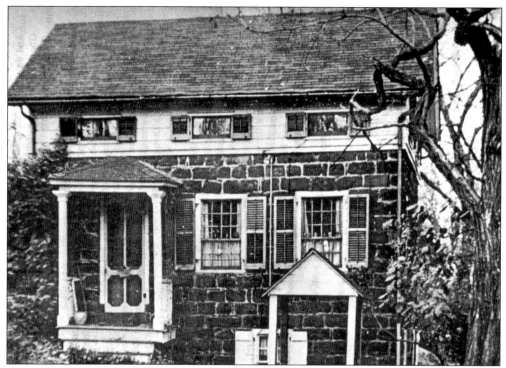

The Naugle House was built in the mid-18th century on Dunkerhook Road, just past the bridge that crosses the Saddle River. Made of stone set irregularly in clay, it does not have the typical features of the Flemish Colonial style seen in many of the other houses of that period. Naugle was the paymaster to Lafayette's troops, and the general himself is believed to have visited the house in 1824.

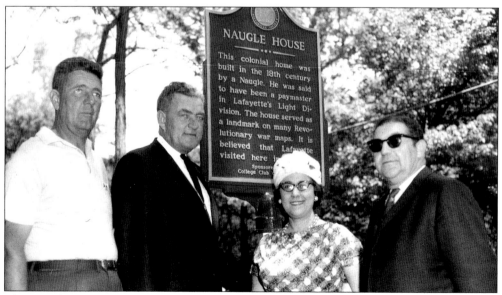

The Naugle House was listed on the National Register of Historic Places in 1983. Mayor Richard Vander Plaat unveiled a plaque marking the house. Attending the ceremony are, from left to right, Melvin Naugle, Mayor Vander Plaat, unidentified, and John Gottlieb.

The Cadmus House was built before 1815, but its history is incomplete. It has a typical dressed stone front, wide-board floors, and hand-hewn beams. Originally located on Fair Lawn Avenue, the Cadmus House was moved to its present site adjacent to the Radburn Railroad Station when it was threatened with demolition. It was listed as the Cadmus-Folly House on the National Register of Historic Places in 1983.

The Van Riper-Ellis House was built for Henry Van Riper, the second son of George Van Riper, in 1862 at the intersection of what are now Morlot Avenue and River Road. George Van Riper's granddaughter Ida Ellis owned the house and 86 acres of land. The house had 15 rooms, three fireplaces, a slate roof, and one-foot-thick brick walls that were covered with wooden siding. It was razed in 1959 to make way for the Van Riper Ellis Memorial Church.

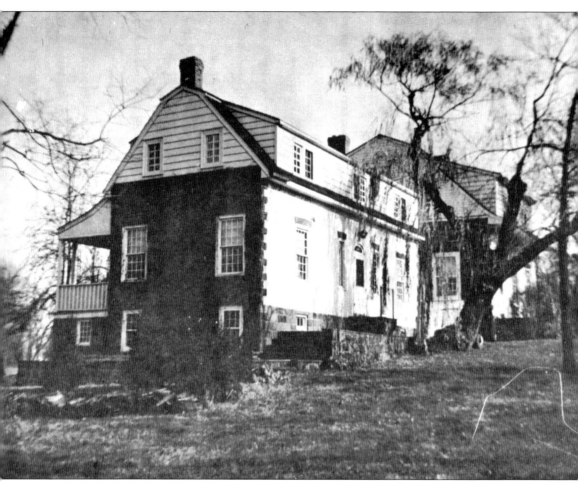

Jacob Vanderbeck Sr. of Brooklyn built the Squire (or Vanderbeck) House in 1734 or 1741 for his son as a wedding present. The house stands on Dunkerhook Road; it was built on a part of a 1,000-acre parcel purchased by William Nicolls in the 1600s. It was made of red sandstone up to the second floor; the interior second floor space remained unfinished and was occupied by children and slaves. During the Revolution, the oldest portion of the house was the headquarters of General Lafayette. Squire added the eastern portion of the house in the 20th century. This house was listed as the Jacob Vanderbeck Jr. House in 1983 on the National Register of Historic Places.

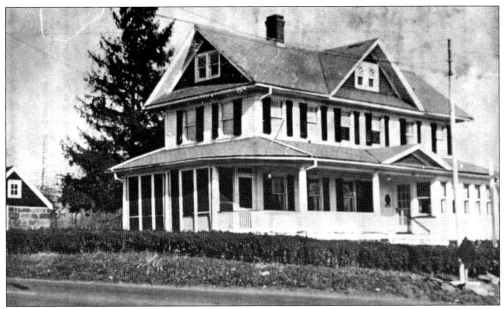

The Ackerman house is at the intersection of Saddle River Road and Fair Lawn Avenue. Currently operating as a restaurant, it is scheduled for demolition. The original front porch was enclosed some years after the house was converted to a restaurant. The ancestral Ackerman who settled in this area was David Ackerman, who left Holland in 1662. Four of his sons settled in this area. His grandson was David Depeyster Acker (or Akker), whose estate, Fair Lawn, is the provenance of the name for the borough.

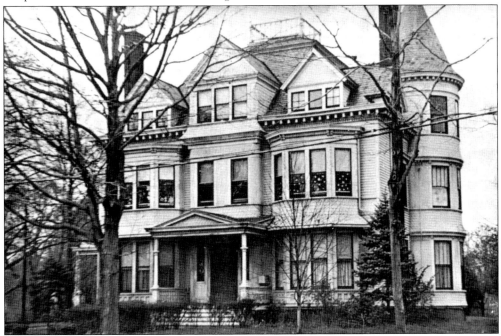

Morlot House (named for the owner, George Morlot) was built in the late 1800s. Morlot, a Frenchman born in 1836, was in the silk-dyeing business in Paterson. Morlot disappeared mysteriously, having last been seen on March 3, 1862. The house was razed in 1964.

Johannes Doremus purchased the property for this house on the north side of Broadway near the junction of the current Route 208 *c*. 1740. The house was built by his son George in 1805 and has since been razed.

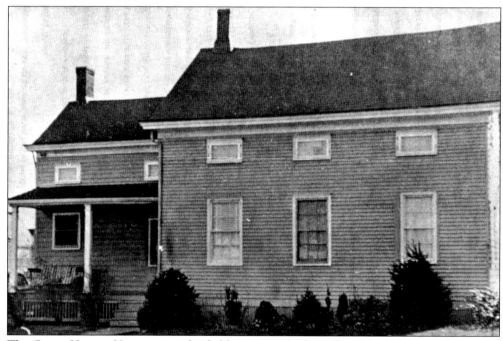

The Garret Hopper House, a wood-sided house, was built in the early 1800s on what is now Fair Lawn Avenue. The original house had a lean-to over a front porch, which has been since altered. For a time it was used as a tavern. The house was sold to the Bogert family, and the Radburn Association acquired it in 1928. It was moved to Warren Road, one block south of its original location, to make room for apartment houses. The house was purchased by Henry "Pop" Milnes and is now owned by Dennis Milnes his grandson.

The Hopper family, descendants of Andries Hoppe (or Hoppen), was among the first settled in Fair Lawn. John Garret Hopper, pictured here, was born on September 23, 1837, in what is now known as the Dutch House. He was a carpenter by trade and built David Depeyster Acker's house on the estate known as Fair Lawn.

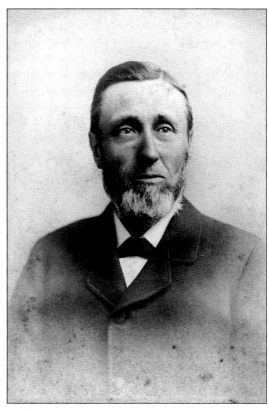

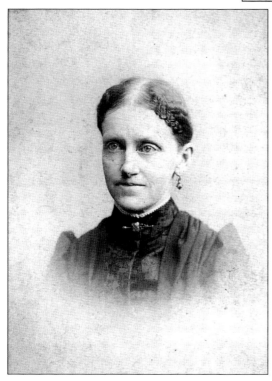

Elizabeth Ann Van Houten Hopper was the wife of John Garret Hopper. They were the grandparents of Edna Hopper and Ann E. Hopper.

Edna Hopper, daughter of Ralph and Minnie Voorhis Hopper, was born on January 12, 1895. She is pictured here with William J. Doremus, the scion of another old family.

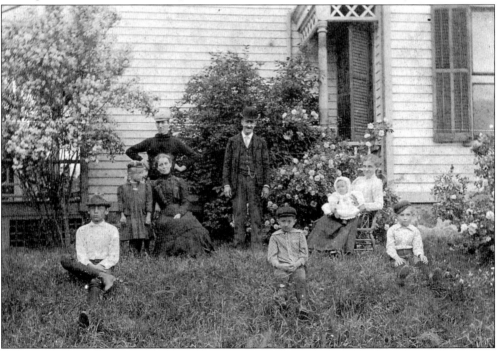

The Strehls, one of Fair Lawn's old families, are assembled in the side yard of their house on Fair Lawn Avenue. The property is shown on the old maps as belonging to John Strehl, a relative of Henry Strehl.

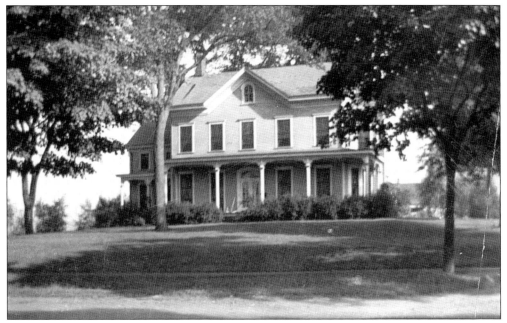

This stately house, built in 1855 on Fair Lawn Avenue, was known as the Sheriff Henry Hopper Homestead. Hopper sold it in 1919 to William Croucher, a member of Fair Lawn's first borough council. In its late years, it housed the offices of state assemblyman Nicholas Felice. The house was demolished in the 1990s to make way for a ramp of Route 208.

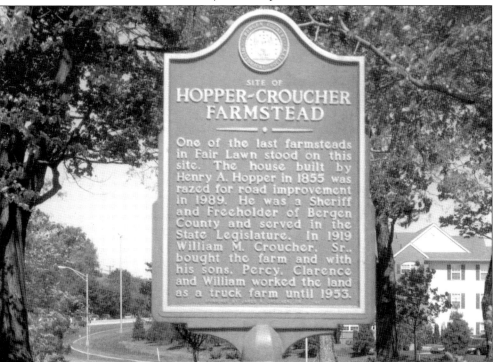

When the Hopper-Croucher House was razed to make way for an exit ramp of Route 208, a plaque and garden were installed to mark the site of the historic homestead.

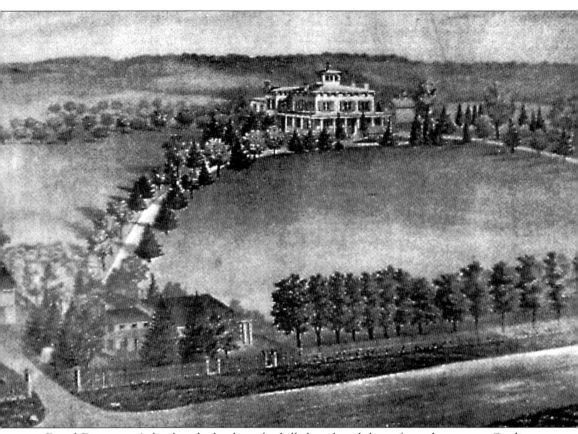

David Depeyster Acker bought land on the hill that sloped down from the current Gardiner Road to Fair Lawn Avenue where he built a homestead in 1865. The spacious lawn in front of the homestead inspired him to name the estate Fair Lawn, which is where the name of the borough originated.

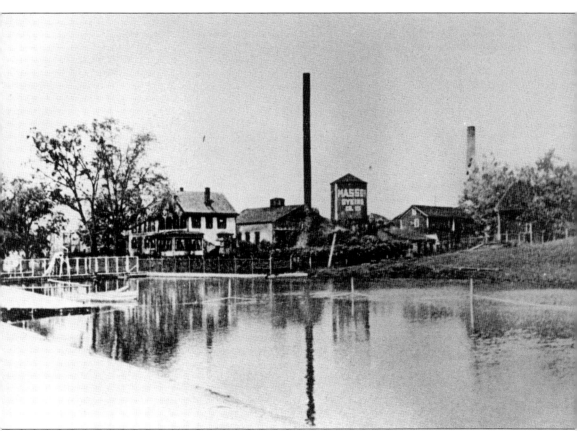

Peter Henderson and his son built and owned Henderson's Bathing Beach (also known as Fair Lawn Bathing Beach) in the 1920s. It was located on the east side of River Road between Fair Lawn and Maple Avenues. Henderson formerly owned an icehouse on the property. The beach operated until the 1940s. The price of individual admission to the facility was about 10¢, and families could also buy passes. A sign at the beach said, "Cool Down and Pep Up at Fair Lawn Bathing Beach." Bathers came from "as far away" as Paterson via bus No. 26, which would make a detour to the beach during the summer.

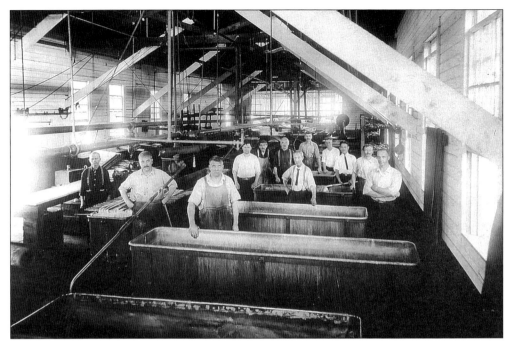

This textile dyeing and finishing company was built between 1900 and 1905 on Morlot Avenue near the bridge over the Passaic River. Many workers in this industry bought houses constructed by the Fair Lawn Land Improvement Association.

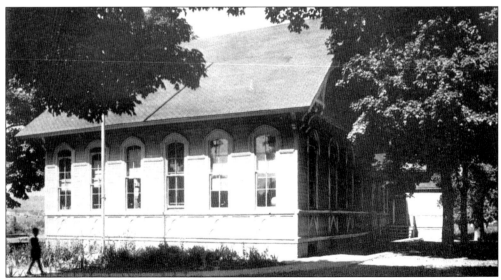

School No. 43 of the Saddle River Township was originally the Washington School on Bergen Street. It was built in 1853 and refurbished in 1873. It is in the Northern European Vernacular style with broad gables with bargeboards and vertical board-and-batten siding. The borough later acquired the building, and it served as the offices of the Fair Lawn Board of Education.

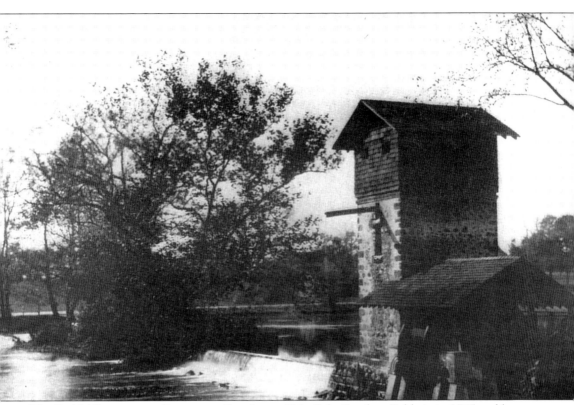

The Red Mill was originally a gristmill and sawmill built by Stephen Baldwin in 1745 and later converted to make woolen blankets and flax during the Revolution. In 1905, Edward Easton constructed the Old Mill on the site of the earlier Red Mill. Easton founded the Columbia Gramaphone Company and built a 26-acre park on this site with fountains powered by the mill. Many movies were shot at this site. Pres. William McKinley and Vice Pres. Garrett Hobart visited the Old Mill.

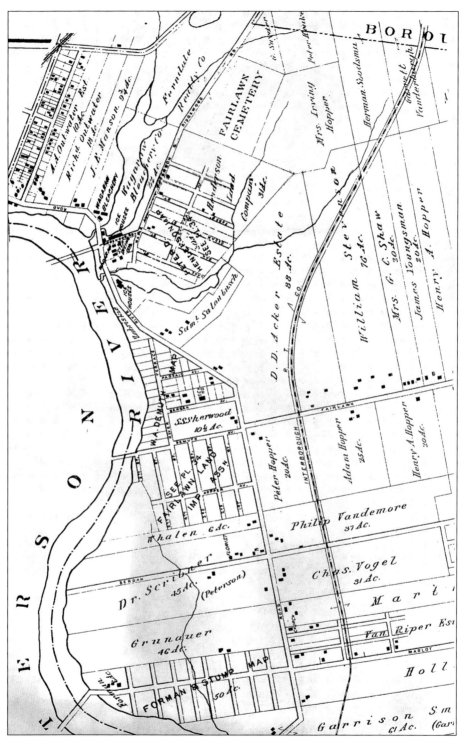

This partial tax map of 1913 shows a section of Fair Lawn's earliest developments that would become Fair Lawn Center, Columbia Terrace and Columbia Heights. Property owners' names, and location of houses are indicated. The dashed line is the path of the Hudson River Trolley line.

Two

From a Farming Community to a Small Town

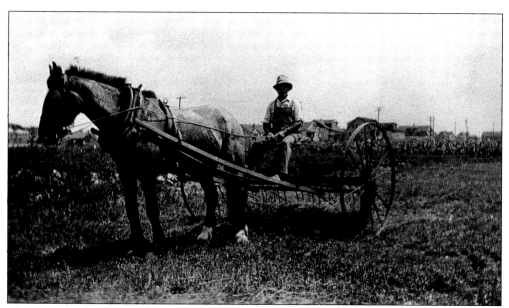

Chief Charles Vogel was the founder of Fair Lawn's Volunteer Fire Department and the first fire chief of Company No. 1. Here he is working on his farm. When the fire alarm sounded, he would unhitch his horses, hitch them to the fire engine, and rush off to the fire. Other firefighters would follow on horseback or in vehicles.

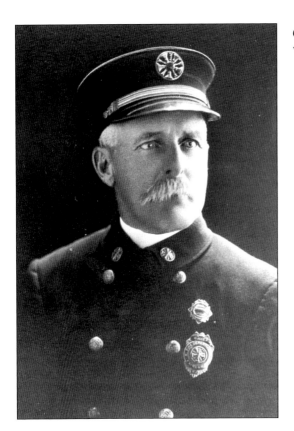

Charles Vogel was the first fire chief of what became Fire Company No. 1.

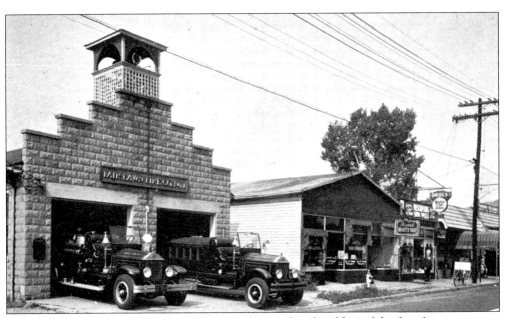

Fire Company No. 1 on River Road (Fair Lawn Center) is the oldest of the four fire companies. The building is now a bagel store; a new firehouse was built nearby on George Street.

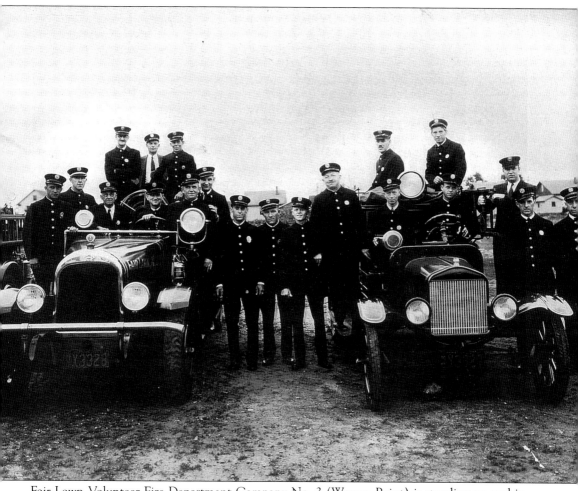

Fair Lawn Volunteer Fire Department Company No. 3 (Warren Point) is standing on and in their two fire trucks in 1933. They are, from left to right, as follows; (front row) Andrew Ryan, Peter Post, Ben Vernooy, Lester Epton, Fred Nuss, Jess Vernooy, Clayton Winters, Ray De Keezil, Threlfall, Charles Aust, Frank Sinema, Don Winters, Frank Wilkes, Leo Roughgarden, and Frank Roughgarden; (in rear on Engine No. 1) Jack De Young, Bruno Willder, and Neil Christmeyer; (in rear on Engine No. 2) Lyle Berridge and Tony Haas.

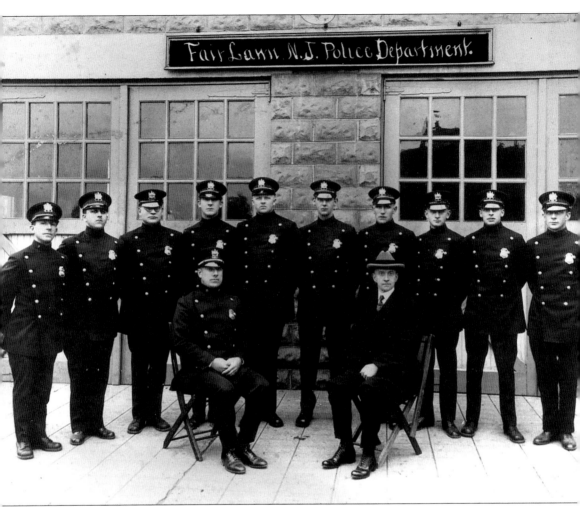

A full-time police force was not created until 1930. Until that time, 13 part-time marshals protected lives and property in the borough. This is how they looked in the late 1920s. Seated in front, council member William Croucher was the first police commissioner and Michael Vanore was the chief marshal.

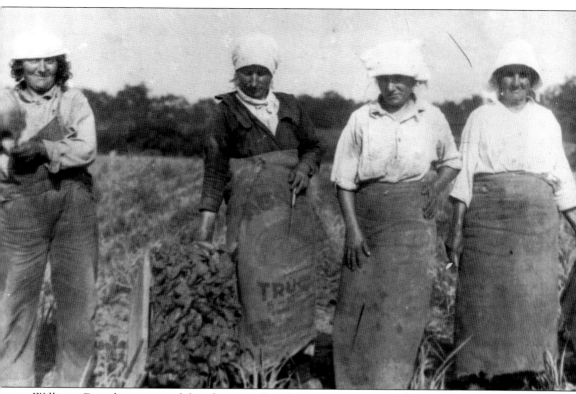

William Croucher operated his farm on Fair Lawn Avenue until the 1970s. The Italian immigrant women in this 1929 photograph worked on the farm. They are, from left to right, Theresa Consalvo, Angelina ?, Carmela Ross, and Louise Vassallo.

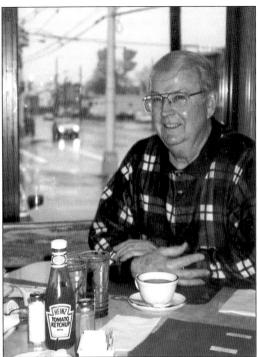

Jim Croucher is a member of the board of the Fair Lawn Historic Sites Preservation Corporation that runs the Fair Lawn Museum at the Cadmus House. One of the longtime residents of the borough, he is the son of William Croucher.

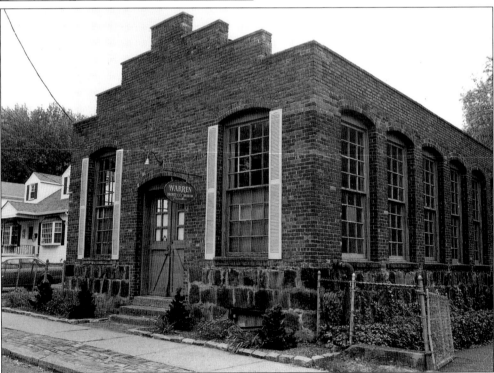

The Warren Foundry, on Second Street, is thought to have been built between 1892 and 1897. Made of sandstone and brick, it displays a stepped roofline typical of the period. Today it operates in the same location as the Warren Bronze and Aluminum Corporation.

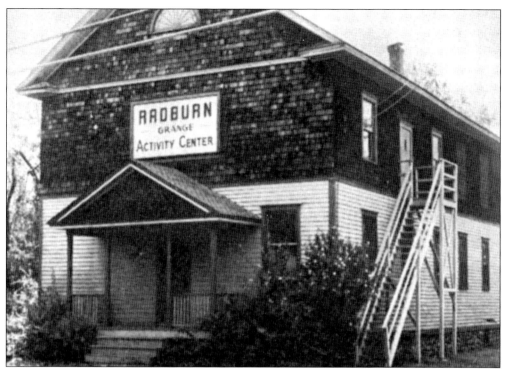

In 1905, the farmers of Fair Lawn organized a Grange to take advantage of wholesale purchasing of supplies and equipment. By 1909, they had raised enough money to build their own Grange Hall, located on Fair Lawn Avenue at Radburn Road. This building was used for social events and meetings of the members, whose number peaked at 150. Members of the Grange sold the building in 1929 to the City Housing Corporation, the developers of Radburn.

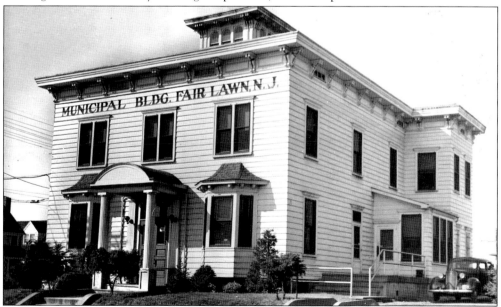

The first municipal building was originally part of the Acker Estate. In 1927, the borough purchased the homestead for $6,500.

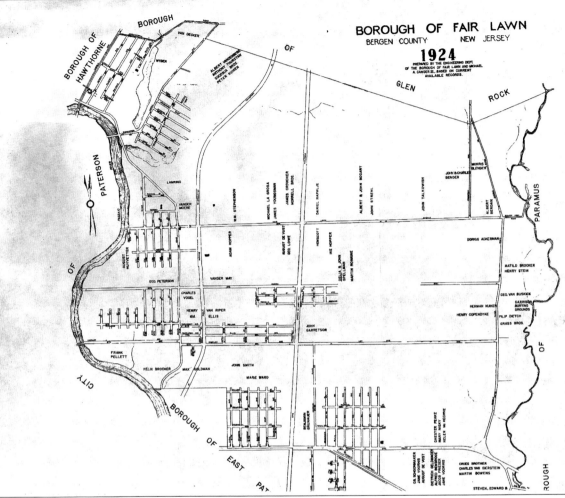

The names of the borough's landowners appear on a 1924 tax map, the year that the borough of Fair Lawn was founded. The main east-west streets were Broadway (Route 4), Morlot Avenue, Berdan Avenue, and Fair Lawn Avenue. The main north-south roads were River Road and Saddle River Road.

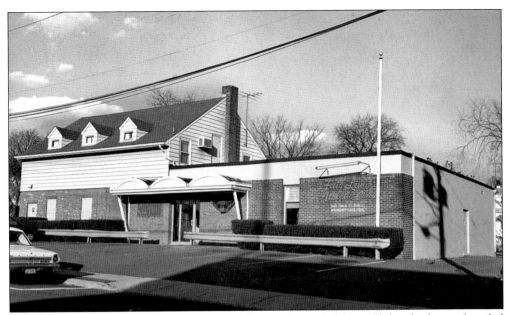

The oldest social and civic club in town is the Fair Lawn Athletic Club, which was founded in the early 1920s by Fred Fox, Arthur Tuschmann, Henry Imhoff, and Jasper Van Hook. The original part of the Fair Lawn Athletic Club building was constructed in 1926. It had four bowling lanes that were removed in 1960 when the club was expanded. It now offers lunchtime dining and catering.

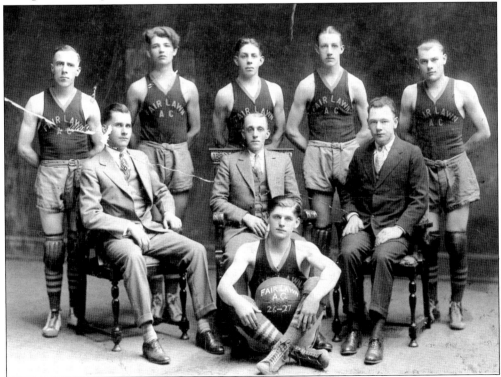

The Fair Lawn Athletic Club fielded several teams, such as this 1926–1927 basketball team.

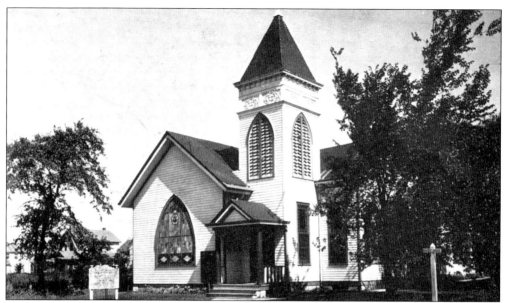

The first section of the Van Riper-Ellis Memorial Church was built on property donated by Henry Van Riper c. 1872 as a Sunday school chapel. It continued to be enlarged by additions through 1942. The church was replaced in 1960 by the present church, which stands on the corner of Morlot Avenue and River Road.

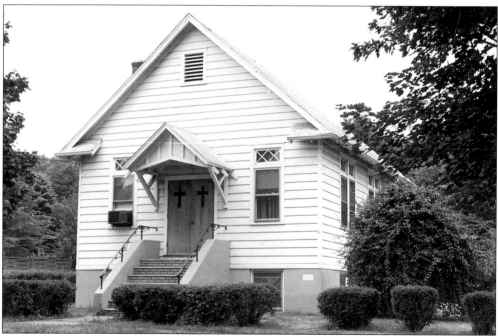

Columbia Heights is one of the oldest sections of Fair Lawn, situated in the northwest portion of the borough. In 1925, members of the neighborhood established a Sunday school, which met in the firehouse. The Sunday school grew so large that the community decided to build a church and hold regular services. They broke ground for the Columbia Heights Community Church in August 1926.

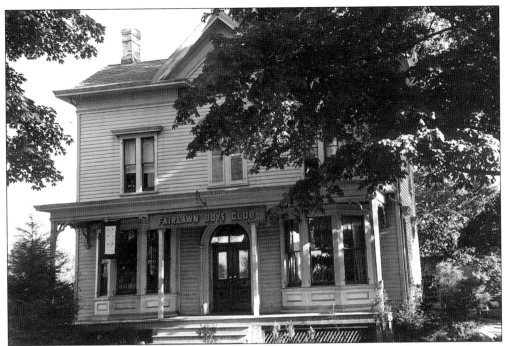

The Fair Lawn Boys Club was established in the Adam Hopper House on Fair Lawn Avenue by Henry "Pop" Milnes and his wife, Esther, in 1939 at the suggestion of Michael Vanore, the chief of police. The Milneses ran the boys club through the 1940s. It sponsored Camp Carlson in Kinnelon during the summers. Its membership rose to 500 by the time the club closed. The club was razed in 1950.

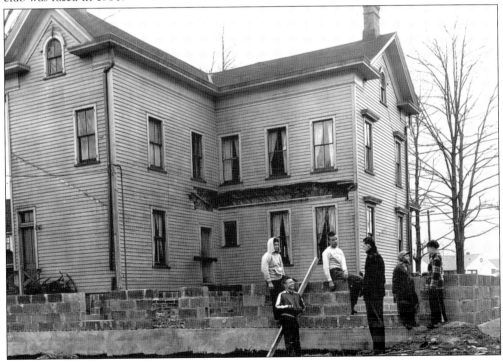

This rustic shedlike structure is the Ranch House Gym, shown in 1942. It was part of the Fair Lawn Boys Club. It had old farm machinery and even a horse and wagon for the boys to drive. It was razed in the 1950s.

Two school buildings, the Roosevelt School and the Washington School, were part of the Saddle River Township school system. When the borough became independent in 1924, both came under the jurisdiction of the Fair Lawn School Board, established in 1925. The name Roosevelt School was later changed to Forrest School in honor of longtime principal John Forrest.

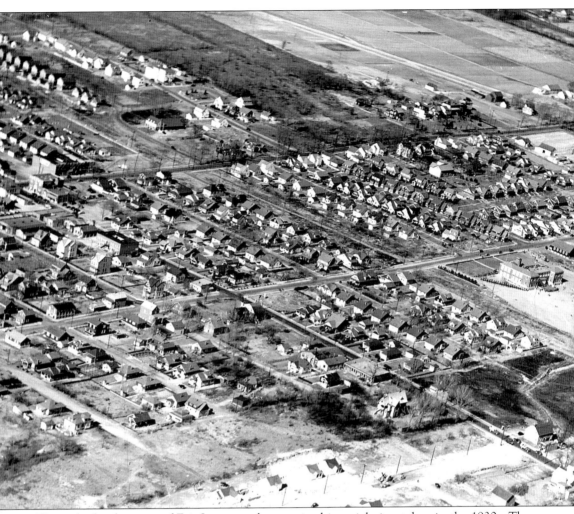

The early development of Fair Lawn can be seen in this aerial view taken in the 1930s. The largest structure is Roosevelt School, at the center right. River Road is the large street that runs from the lower right to the upper left. Note the absence of traffic.

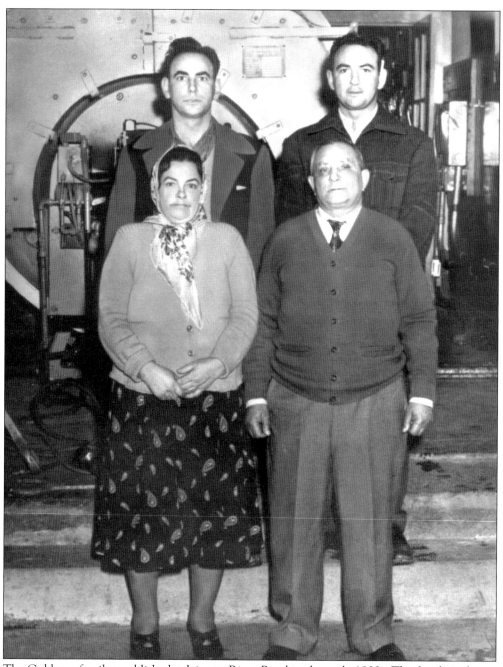

The Goldman family established a dairy on River Road in the early 1900s. The family is shown here standing in the processing plant in the 1940s. Max and Bessie Goldman are in the front row; their sons Jacob and David are in the back row.

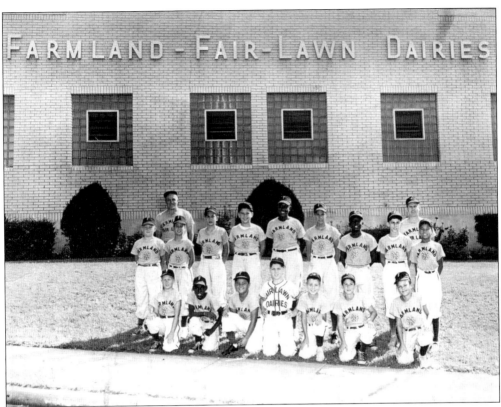

Farmland-Fair Lawn Dairy, as Goldman's dairy was known, sponsored a baseball team.

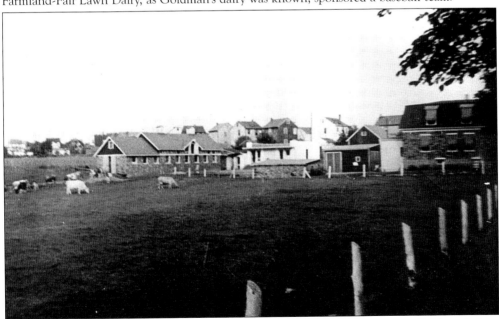

Fair Lawn had several dairies its early days. The last two functioning ones were Goldman's dairy (Farmland-Fair Lawn Dairy) on River Road and Lamring's dairy, seen here in 1939. Lamring's was a few blocks from the present municipal building.

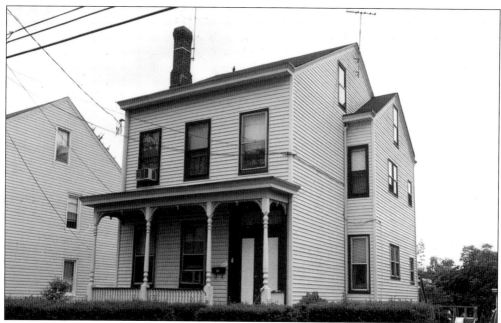

The Fair Lawn Land Improvement Association built many homes near the Passaic River between 1890 and 1913. They were built for workers in the mills of Fair Lawn and Paterson. This 1890 house on Third Street is a two-and-a-half-story structure built in the vernacular style with Italianate and Queen Anne features. With bracketed cornices and a patterned frieze, it is one of the most elaborate in the district.

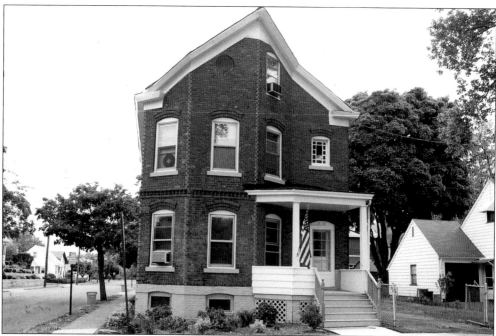

This house, built c. 1890 in the vernacular style, is on Fourth Street. It has an unusual angled roofline adjusted to the projecting façade bays. It has interesting brick accents and triple arches over the windows.

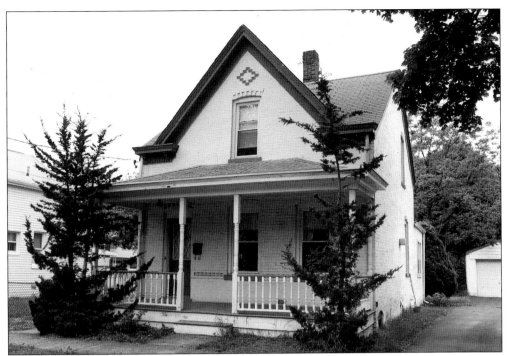

This Fifth Street house, built *c.* 1913, is a one-and-a-half-story brick structure in the vernacular style. It is cross-gabled with bracketed returned eaves on the façade and decorative brickwork over the windows and front gable.

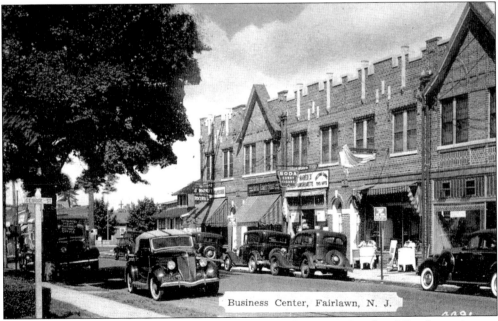

Business Center, Fairlawn, N. J.

A bustling retail and service area was already developed on River Road and Fair Lawn Avenue in Fair Lawn Center by the 1930s. The two-story buildings on the north side of the street had apartments above the street-level businesses. This is a view looking west on Fair Lawn Avenue from George Street.

"Be Kind to Animals"
EXHIBITION
FAIR LAWN POLICE DOGS

October 15th, 1932, 2:30 P. M.
Radburn Base Ball Field, Fair Lawn
Benefit Fair Lawn Milk Fund

PROGRAM

FIRST TEST

In this first trial of the dog's skill, he will be required to find some hidden article. His task will be made difficult for him by having two or more strangers cross the trail of the person who hid the article which the dog must find.

SECOND TEST

In this second trial two articles will be hidden. The dog will be required to bring home the specially designated one; if he brings home the other one, he will have failed to do what was required of him.

THIRD TEST

In this test of the dog's intelligence four or five separate articles will be hidden in the trail which the dog must follow. One of these articles will be hidden by the dog's master. The dog must bring back the article hidden by his master or he will fail in doing what is required of him.

FOURTH TEST

This test will show the dog acting as a dispatch carrier. This test is designed to prove the dog's training causes him to understand just what he must do. These dogs were used extensively during The World War as dispatch carriers; as food carriers to the men in the trenches; and as bearers of wire to repair telephone wires in shell torn sections.

This dog will be given a message with instructions where to take it. He will also be instructed to bring back an answer. Watch him do it!

FIFTH TEST

LUX—Obedient. Heeling on left side with and without leash. Lying down on command, lying down and remaining until called. Sitting down on command, carrying objects and holding same until given command.

SIXTH TEST

FERRA—Obedient.

SEVENTH TEST

Refusing food offered by stranger.

EIGHTH TEST

LUX AND FERRA.

NINTH TEST

Character of Lux.

TENTH TEST

Ferra Manhunt.

ELEVENTH TEST

Ferra fearlessness of blows and shots.

TWELFTH TEST

Specialty.

THIRTEENTH TEST

Alley jumping and climbing ladder.

Henry Landzettel trained German shepherds as police dogs. He was a member of the Fair Lawn Auxilliary Police as well as the founder of Landzettel & Sons Paints, later called Lazon Paints and Wallcoverings. This poster, which advertised a charity exhibition of his dogs, dates from 1932.

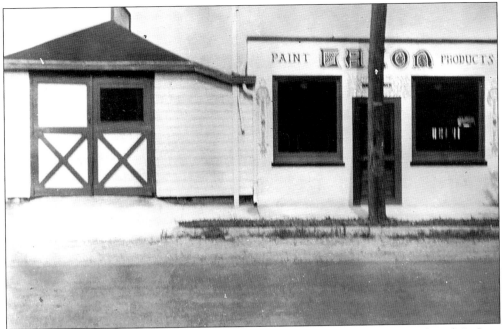

Henry Landzettel, along with his sons Walter and William, founded the Landzettel & Sons Paint Company in 1932. They manufactured and sold their products from a small factory on Fourth Street. Henry, who learned the art of paint mixing in Germany, was a painting contractor until he opened this business from his home.

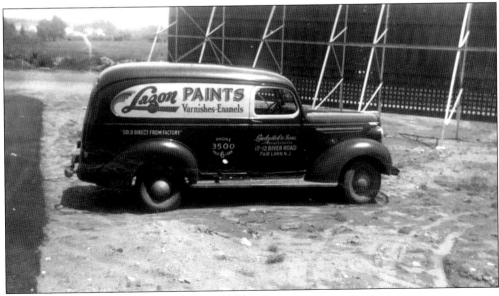

A Lazon delivery truck is shown in June 1950.

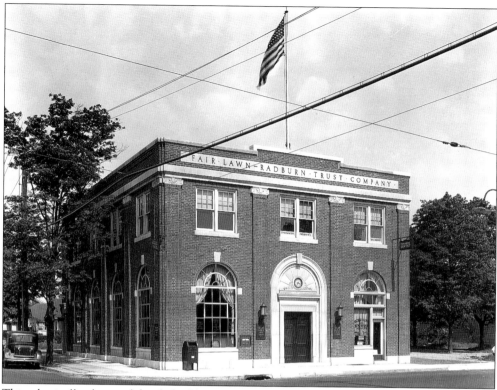

This classically designed brick building, the Wyder Building, was constructed in 1929 at River Road and Fair Lawn Avenue. It was used as an office building and was later the Fair Lawn-Radburn Trust Company. It now serves as a branch of the Bank of New York.

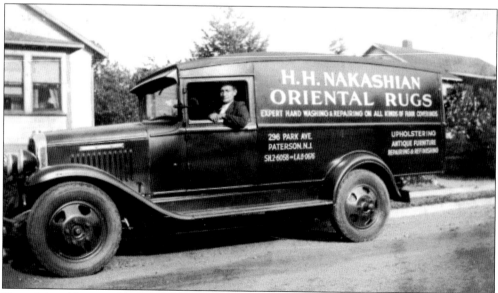

One of the oldest retail businesses in town is Nakashian Carpets, founded by Harry Nakashian. His sons John and Jack are now the proprietors of the business on Broadway. Harry Nakashian is seen driving his delivery truck in 1936.

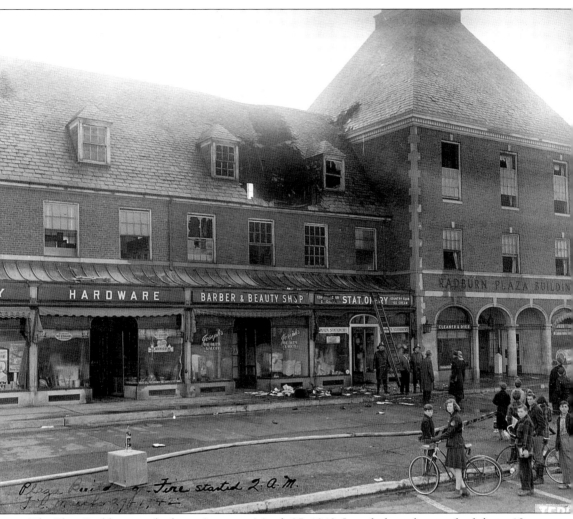

The Plaza Building caught fire at 2 a.m. on March 27, 1942. It took the volunteer firefighters 12 hours to extinguish the flames. The fire caused more than $150,000 in damage. The community supported their efforts by serving food to the volunteer firefighters.

The Organization Meeting of the Mayor and Council of the Borough of Fair Lawn was held in the River Road Fire House on the Second Day of June, 1924.

There were present: Mayor, Robert A. Smith, Councilman William M. Croucher, Jr., Richard Shortway, Andrew E. Fox, James N. Hyslop, Garret Houtsma and William F. Hill, collector of Taxes Harry T. Shannon and Assessor Lukas Kuiken.

All Officials were duly sworn in and qualified. Mayor Robert A. Smith delivered the following address.

Gentlemen of the Council:

It now becomes our duty to launch the new ship of state, "The Borough of Fair Lawn" upon its voyage into the great unknown future, with yourselves as the crew and I as your Captain and I sincerely pray, that with the help of God, that we may guide our craft through the many shoals and channels of civil life in safety, so that when we return to our port, our fellow men and women will say "Well done thou good and faithful servant."

I need not remind you at this time, that the eye of our townfolks, are, and will be, for sometime to come upon us, to see how we care for and nourish the infant municipality that has been placed in our custody; for I am sure that you are well aware of that fact.

However, I do want to impress upon you the necessity of sound sense, carful and practical deliberation upon your future ministering to its need and requirements in order that it may develop and grow to a healthy and prosperous town second to none in the County of Bergen and be worthy of its title "The Garden Spot of New Jersey."

To you the administration of Public affairs is something that you have never before been engaged in, but your have been placed here by our townspeople because you bear reputations of honesty, ability and fair dealing in your various vocations and you are, expected to apply those qualities in the administration of the business affairs of our borough with the same reasoning and juris-prudence as you do to your own business.

Your path is not going to be one of roses. Your are going to meet with obstacles, which at times are going to be hard to overcome; in fact many of them will sorely try your patience. You will meet with rebuffs, criticism, and very often abuse that will test every fiber and caliber of your manhood to the extremes of endurance, and the manner in which you meet these barriers and overcome them shall determine your future right to leadership among your constituents.

You will be approached from all sides; both, within and without the Council Chambers, by individuals and small coteries, for special favors and requests that will be represented to you as being the desires of the Public at large and I wish to take this opportunity of advising you against the making of any pledges for the support of these projects, until your have first assured yourselves and determined that there is a public and popular demand on the part of the general public for the same; in other words "Be Sure You're right, then go ahead."

It becomes your duty to legislate wisely for the benefit of the people within the territorial limit of the Borough. All ordinances, street maintenance, repairs, lighting, expenditures, improvements, taxations and the supervision of the routine business of the Borough shall come within your jurisdiction.

It becomes my duty to consult and advise your upon these matters, to peruse and scrutinize the wisdom of your actions and proceedings upon all matters pertaining to the Public and I sincerely hope that we shall cooperate with each other for the mutual benefit of all. Remember, Gentlemen of the Council, that we have been elected to our respective office, upon a platform of economy with which you are all familiar and I herewith charge you with the specific performance of your duties in accordance therewith.

In closing Gentlemen, let met suggest, that we all put our shoulders to the wheel, with the foreword "ONWARD" for a greater, bigger and more prosperous BOROUGH OF FAIR LAWN.

> Respectfully submitted
> (Signed) Robert A. Smith - Mayor.
> Dated June 2, 1924

Fair Lawn celebrated its 75th anniversary with numerous events held during the entire year of 1999. Individuals, civic groups, former municipal officials, and longtime residents all participated in the celebrations organized by scores of volunteers. A reenactment of the first council meeting of June 2, 1924, started with an address, reproduced here, which was given by Mayor Robert A. Smith on that date.

Three

RADBURN

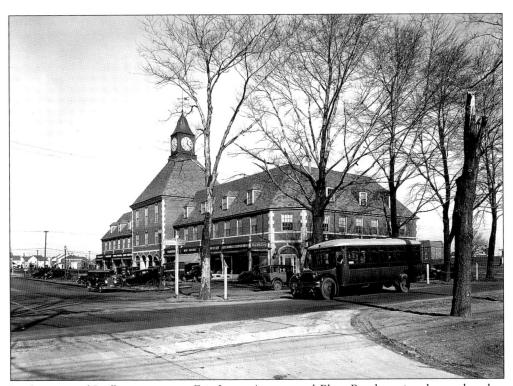

In this view of Radburn center at Fair Lawn Avenue and Plaza Road, notice the modern bus traveling on its route going down Fair Lawn Avenue. In the right rear, you can see the three-story Abbott Court Apartments.

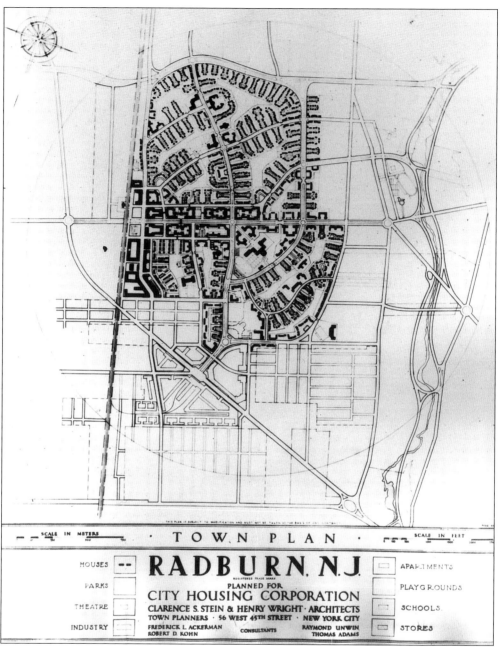

· T O W N P L A N ·

SCALE IN FEET

HOUSES

PARKS

THEATRE

INDUSTRY

RADBURN, N.J.
REGISTERED TRADE MARK

PLANNED FOR
CITY HOUSING CORPORATION
CLARENCE S. STEIN & HENRY WRIGHT · ARCHITECTS
TOWN PLANNERS · 56 WEST 45TH STREET · NEW YORK CITY
FREDERICK L. ACKERMAN CONSULTANTS RAYMOND UNWIN
ROBERT D. KOHN THOMAS ADAMS

APARTMENTS

PLAYGROUNDS

SCHOOLS

STORES

This is the map of Radburn rendered by the City Housing Corporation. The architect-planners, Clarence S. Stein and Henry Wright, solicited the help of financier Alexander Bing to organize this development in 1924. Construction began in 1928. It was originally planned as a community for 25,000 people, but work stopped when the corporation went bankrupt during the Great Depression. The community then numbered 5,000 people. Radburn, one of the first planned communities in the United States, was listed on the National Register of Historic Places in 1975. The community encompasses a school, the Grange Hall, the Plaza Building, a railroad station, two swimming pools and tennis courts, in addition to detached houses, row houses and an apartment complex, and several areas of central parks.

48

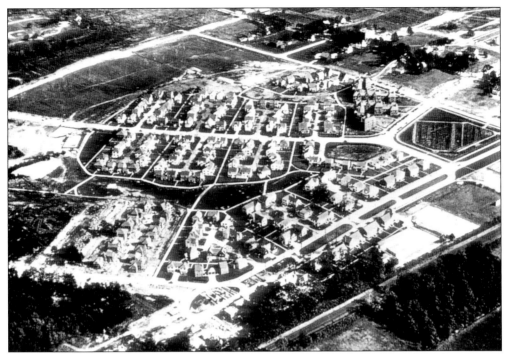

This aerial view of the north side of Radburn shows the two sides of B Park with commons in the middle and the A Park across Howard Avenue (which runs through the center of the photograph).

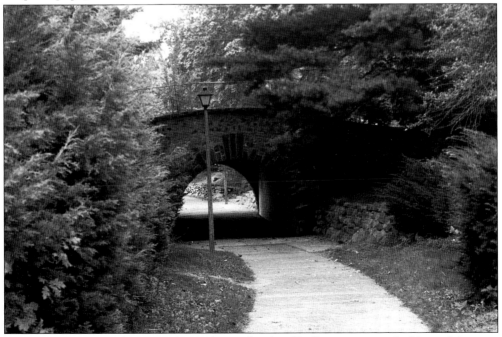

A tunnel connecting the two parks on the north side of Radburn passes under Howard Avenue. To get from the north to the south side of Radburn, one has to cross Fair Lawn Avenue at a traffic light or with the help of a crossing guard.

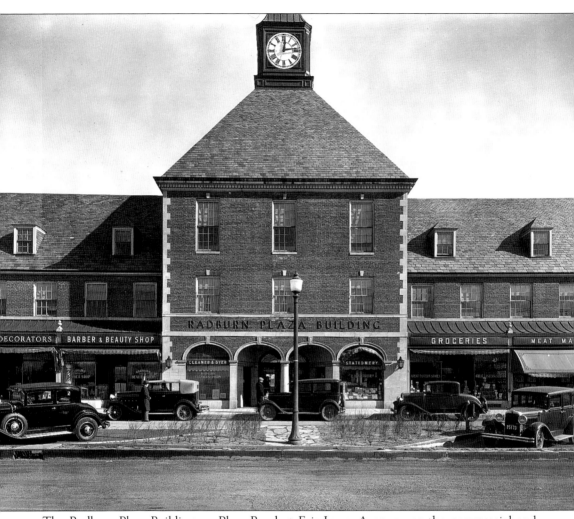

The Radburn Plaza Building on Plaza Road at Fair Lawn Avenue was the commercial and social center of the Radburn development. A long brick building topped by a clock tower, it housed the offices of the City Planning Corporation, builders of Radburn, as well as retail establishments on the first floor. Offices and the Radburn "Club," or meeting room, were on the second floor.

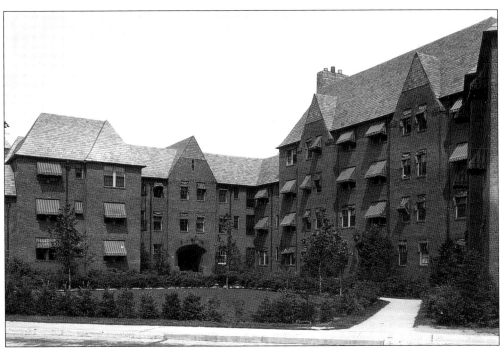

An innovative plan, Radburn incorporated three-story multiple housing units along with single family and row houses into the design of the community. This apartment complex known as the Abbott Court Apartments is located in A Park.

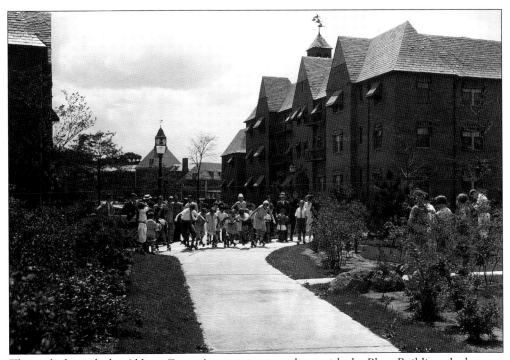

The path through the Abbott Court Apartments, seen here with the Plaza Building clock tower in the background, was the site for this roller-skating race.

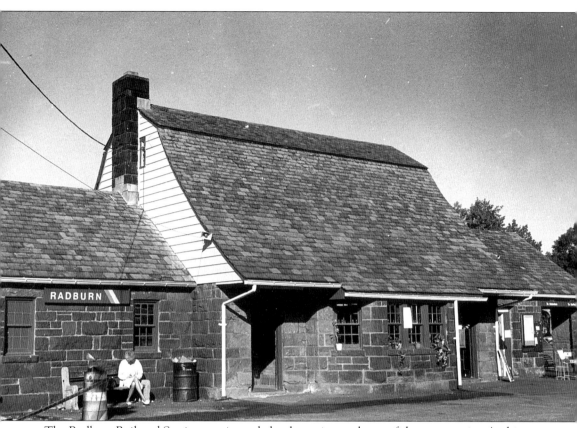

The Radburn Railroad Station was intended to be an integral part of the community. Architect Clarence Stein designed it in 1930. An example of the Dutch Colonial Revival style, it is characterized by its sandstone façade and a side gambrel roof. The railroad came to Fair Lawn as early as 1831; the main line was chartered as the Paterson-Hudson Railroad in 1831 by a group of Paterson executives and was acquired by the Erie Railroad in 1850. New Jersey Transit now runs the railroad. This station was listed on the State and National Register of Historic Places in 1975, along with the entire Radburn development.

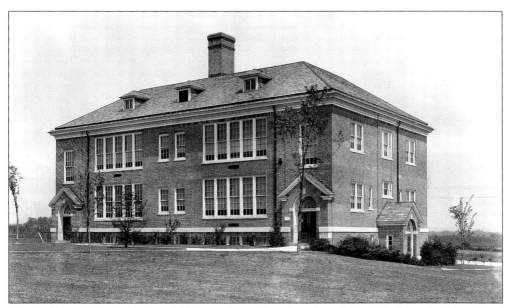

The Radburn School, built in 1930, was located at the edge of the B Park on Radburn Road to minimize the need for children to cross a street to get to school. A new wing was added to the north side of the building to accommodate Fair Lawn's children as the growing population developed around Radburn.

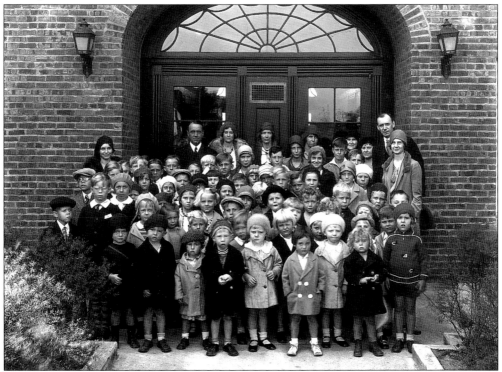

Some grumpy, some smiling, these children pose with their teachers for their official Sunday school picture. The class met in the Radburn School, which can be seen in the background of this 1930s group photograph.

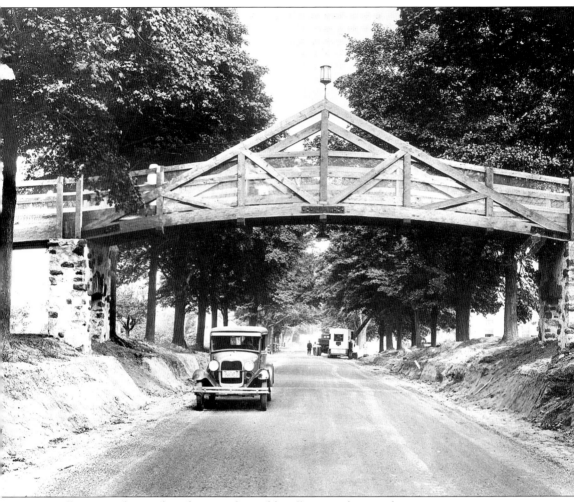

Radburn was designed so that people could walk everywhere without crossing a major street. This 1930 view of Fair Lawn Avenue shows the pedestrian bridge that crossed Fair Lawn Avenue connecting the north and south sides of the community. The bridge was taken down in the 1950s when Fair Lawn Avenue was widened. It was never replaced.

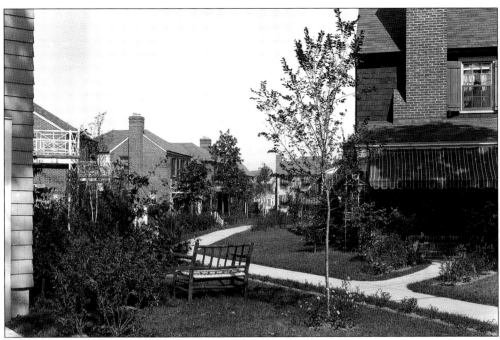

The front entrances to Radburn houses were approached from the paths that wound through the parks. Neighbors were supposed to walk, rather than drive, to visit one another. Houses varied in style even on the same street. Some houses shared a common wall; others were free standing. Some blocks on the south side had row houses exclusively. The views shown here are typical of the park side of two streets. Although the architectural committee of Radburn strictly limited modifications to the outside of the houses, families made individual statements with landscaping. Strollers walk through Radburn in the spring admiring one another's horticultural achievements.

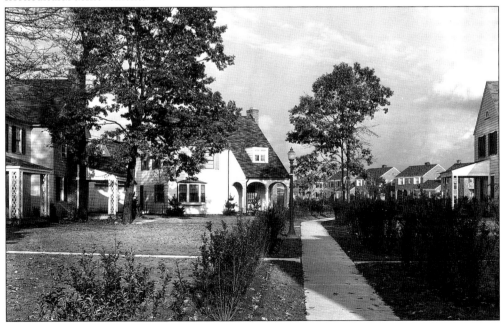

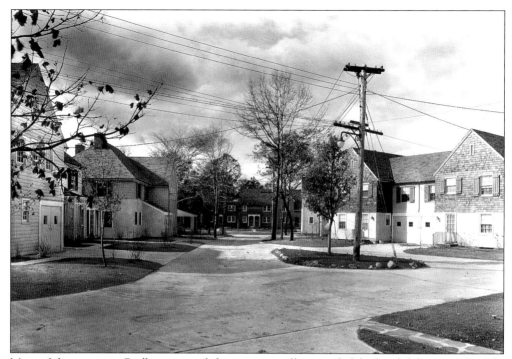

Most of the streets in Radburn are cul-de-sacs originally intended for local deliveries of goods, services, and parking of residents' cars. The rear entrances to the houses opened onto these dead-end streets. Bolton Place, a typical street on the north side, has a turn-around at the end of the cul-de-sac.

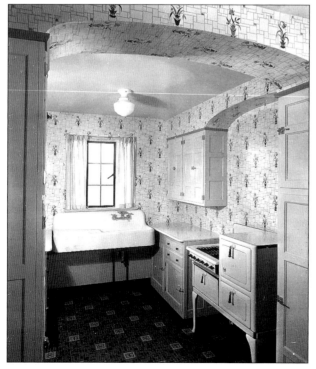

The latest in kitchen design is shown in this 1930 Radburn model house. An icebox (later called a refrigerator) was placed on the wall opposite the four-legged stove.

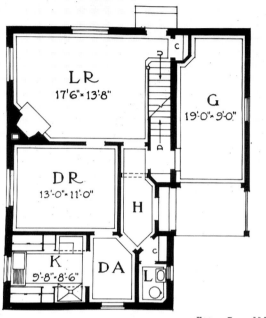

LR
17'6"×13'8"

G
19'0"×9'0"

DR
13'-0"×11'-0"

H

K
9'-8"×8'-6"

D A

L

c

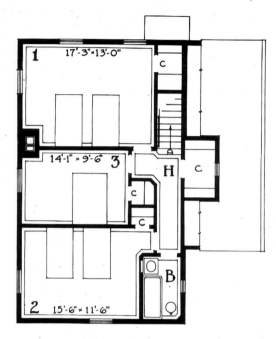

1 17'-3"×13'-0"

c

14'-1"×9'-6" 3

H c

c

c

2 15'-6"×11'-6"

B

House Type 113

The single-family house, type 113, featured the kitchen shown in the previous photograph and had three bedrooms and one and a half bathrooms. There was no such room as a family room; the family assembled in the living room or on a summer porch attached to the front of the house.

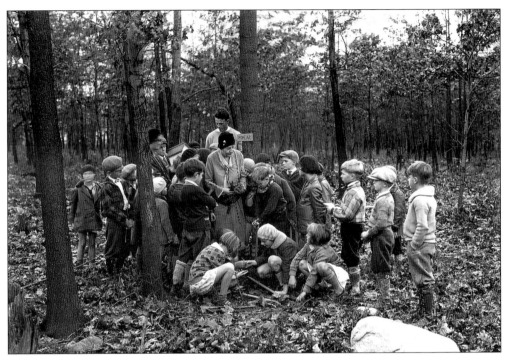

Nature was never very far away for these children. A Radburn School teacher is helping them identify trees by the leaves and branches littering the floor of the nearby woods.

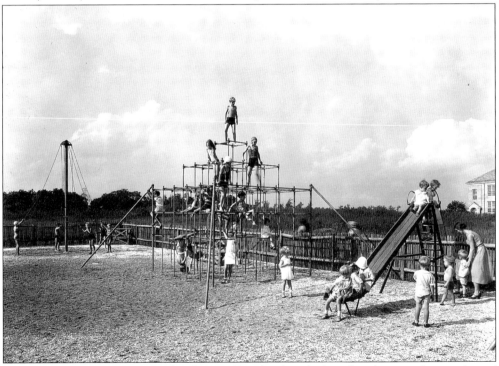

The land behind the Radburn School was still undeveloped when this photograph was taken of children climbing on the monkey bars.

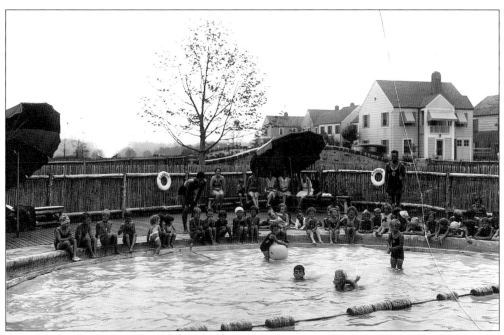

Everyone looked forward to Memorial Day, when the two Radburn swimming pools would open. Free swimming, lessons for the children, and competitions with teams from neighboring towns were all part of the summer program. Having a pool within walking distance was one of the advantages of living in Radburn. Children as young as three take swimming lessons, and older children look forward to the day that they can pass the test that allows them to come to the pool without an adult. These 1930s photographs show the children swimming and diving under the watchful eyes of their instructors.

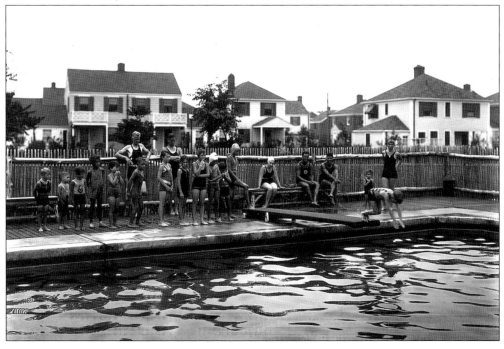

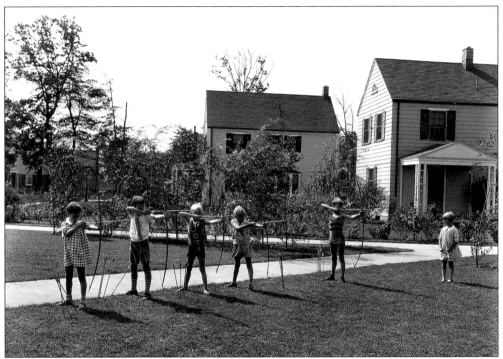

The many acres of Radburn commons are used year-round by the residents for sports, a children's day camp, outdoor plays, or just walking. The top photograph shows children practicing archery in the park. The practice field for this sport was later relocated to Archery Field, a sliver of land off Fair Lawn Avenue near the railroad. Croquet was a popular activity for the children, seen playing here on the wide lawn of B Park.

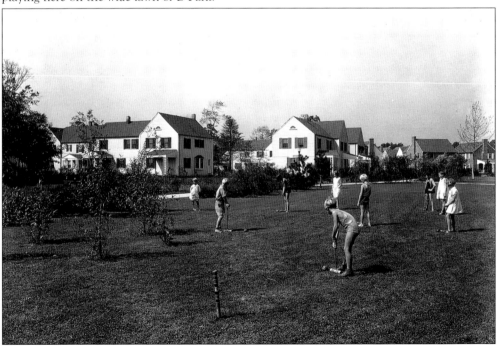

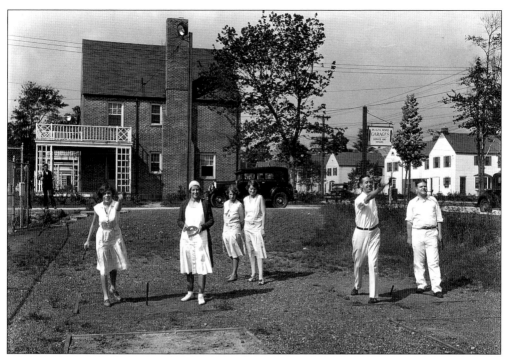

A warm summer day brought out folks for a friendly game of horseshoes. The court was on Plaza Road where, a few years later, tennis courts would be constructed.

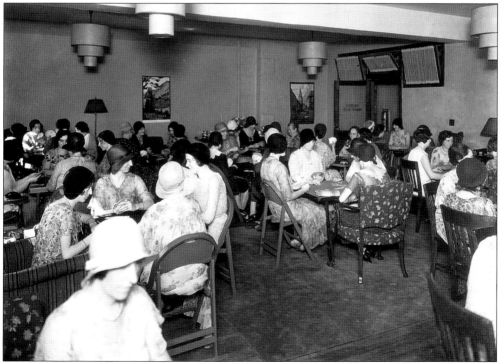

An afternoon of bridge and other card games in the clubroom of the Radburn Plaza Building was a regular activity for many women.

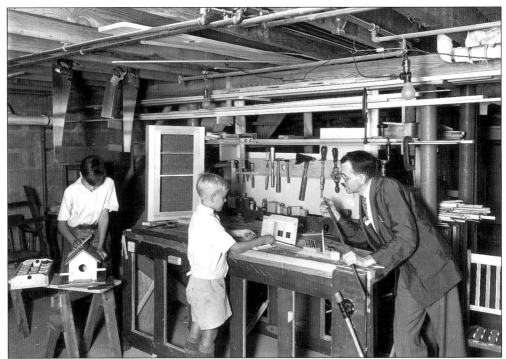

A fully equipped woodshop in the basement of the Radburn Plaza Building was available for those interested in constructing small projects, such as the birdhouses seen here, and larger projects, such as bookcases and dollhouses.

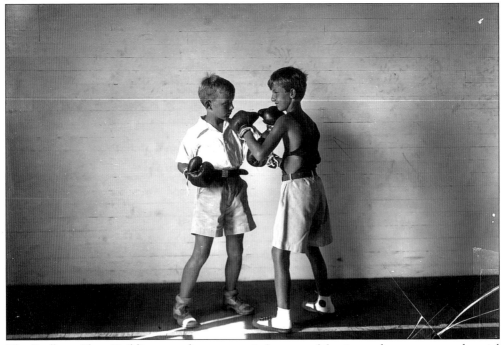

The Radburn Plaza Building was the community's center. Meetings, plays, sports, and social events were but a few of the activities that went on. Two boys are seen here practicing boxing.

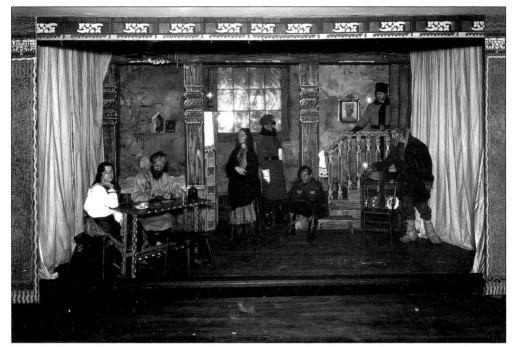

The Radburn Players, an amateur theater company, has been performing since the very inception of the community. They produce several plays each year, at least one in the park during the summer. Originally, the plays were staged in the Radburn Plaza Building; now they are performed in the Grange Hall.

The Radburn Players, in full costume for a western drama, pose for an ensemble photograph during the 1930s. The group is the oldest continuously performing little theater in New Jersey.

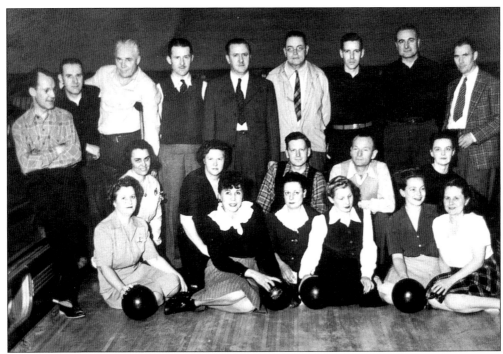

Another favorite activity for Radburnites was bowling. The bowling league pictured here would have had to take their game to a local alley because Radburn did not have one of its own.

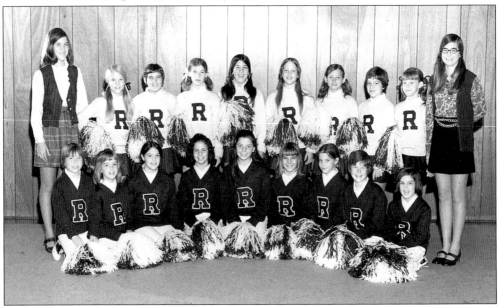

The cheerleaders of Radburn in the 1970s are decked out in their "R" sweaters and pompoms ready to spur on the local teams to victory. Pictured, from left to right, are the following: (front row) Judy Lyman, Susan Cook, Joy Mancini, Phyllis Harris, Lynn O'Malley, Jill Muhr, Christy Andrews, Kristi Lamm, and Terri Fox; (back row) Maura Fox, Susie Enterline, Karen Ryan, Kitty McGovern, Mary McGovern, Kristen Kearney, Jodi Weissman, Karen Pizzo, Jenny Andrews, and Joanne Meade.

Four

A COMMUNITY EFFORT BUILDS MEMORIAL PARK

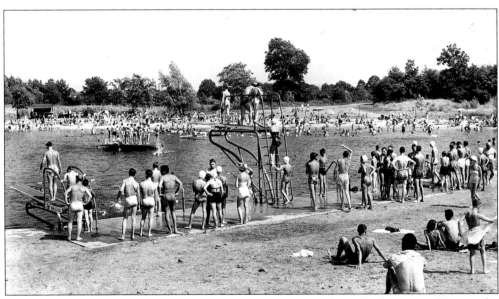

Memorial Park and Pool, the largest park in Fair Lawn, runs alongside the Passaic River at the end of Berdan Avenue. The park has areas for picnicking, sports, and just relaxing under the trees. The pool is a sandy-bottom impoundment 3,000 feet in width; it reaches a depth of 14 feet. The entire complex was organized and built by a volunteer committee with donations of money, materials, and labor. It opened in 1949.

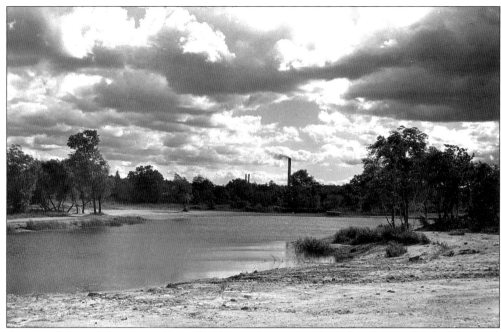

A spring-fed pond that drained into the Passaic River was selected as the site for the Memorial Pool. Affectionately called "the sandpit," it is shown here before the construction started. The smokestacks in the rear are on the other side of the Passaic River in Paterson.

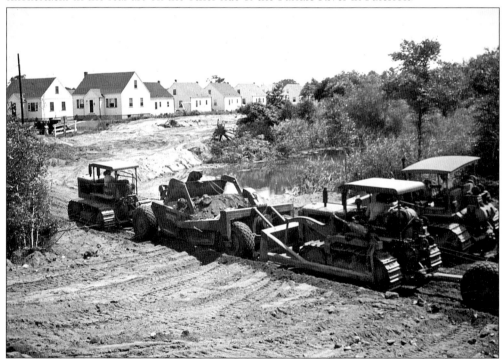

An army of earth movers rolled onto the site to grade the road to Memorial Park, which was being carved out of a 33.5 acre site. Many construction companies supplied materials and labor for the project. Frank Stamato & Company supplied these bulldozers and carryalls.

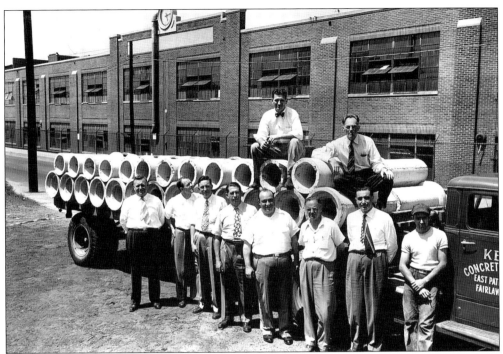

Scores of volunteers and donations of material and labor by hundreds of individuals and business made it possible to realize the dream of Memorial Park and Pool. Stanley Carlson donated 200 feet of 12-foot pipe. Pictured, from left to right, are the following: (front row) Dominick Jordan, Dave Langkammer, Gil Hale, Dr. Maurice Pine, Mike Canger, Stanley Carlson, Judge Morris Dobrin, and unidentified; (back row) Dr. Loeffler and Cameron McCurdy.

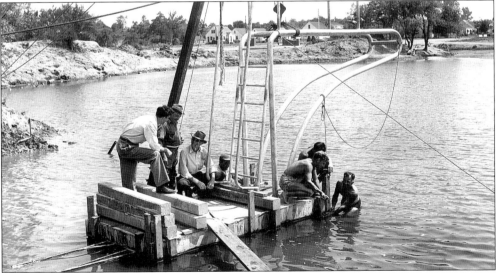

Volunteers constructed diving boards and a raft at Memorial Pool. All the men in this photograph are volunteers working with recreation superintendent Monte Weed, seen on the left. Cameron McCurdy, Fair Lawn's postmaster, was president of the Fair Lawn Memorial Park Civic Association, the organization responsible for organizing and executing the entire project. He appears in this photograph with a cigarette holder in his mouth.

Donation of Materials and Services

by Individuals and Firms

Peter Shortway, 2½ days excavating	150.00
Canger Contracting Co.	500.00
Stanley Carlson, 200 ft 12" pipe @1.20	240.00
Plymouth Park Homes, 52 ft. 12" @ 1.20	62.40
Vogel & Wolfinger, 100 ft. 12" pipe @ 1.20	120.00
Vander-Meade, 24 yds. dust @2.10, 50.40	
172 tons quarry stone @2.50, 430.00	480.40
Terrace Auto Wrecking bulldozing	125.00
Al Daloisio, bulldozing	75.00
Kulken Bros., lumber for bath house	500.00
Glen Rock Lumber lumber for bath house	300.00
Service Bldg. Co., doors & windows, bath house	300.00
J.Ghauger, plumbing for 1 bath room, bath house	366.14
Bee Electric Co., complete wiring for bath house	125.00
Painter for bath house	100.00
Thornton Gorlick, 1 row boat	75.00
Radburn Supply Co., 1 row boat & fire bricks	100.00
Joseph Ulinski, 1 row boat	50.00
Hawthorne Block Co. 380 cement blocks	56.16
J. Tanis Sons, 6 cu. yd. poured concrete	54.00
Horbatt & Co., compensation for life guards plus materials	
and equipment	400.00
Kimball Printing Co. printing	150.00
Kremers Press, Printing	150.00
F. Stomato, road work and grading grounds	1200.00
Sam Braen, concrete and crushed stone	400.00
Brewster Co., work on grounds	1000.00
Home Improvement Co., grading Beach	800.00
Meserole Landscapers	200.00
Canger & Bailey, engineering	1000.00
F.E. Harley, civil engineer	500.00
United Piece Dye Works, 12" control valve	300.00
Alex Hearle, drag line	100.00
Leo Roughgarden, float deck complete	125.00
	10004.10

The construction of Memorial Park was truly a public effort. Donations of material and services for the entire project totaled $10,000. By the time the park opened, $11,000 had been raised in private donations.

Memorial Park was formally dedicated on May 29, 1949. The entire town was invited to the celebration; speakers at the event represented civic organizations, veterans, and the clergy. Director Monte Weed spoke for the recreation department. They had all worked to make the dream become a reality.

+⊁⊰ DEDICATION PROGRAM ⊱⊁+

CHAIRMAN OF CEREMONIES Mr. Michael A. Canger, Jr.
Fair Lawn Men's Club

NATIONAL ANTHEM ... William J. Klepper
Fair Lawn Choral Society

INVOCATION ... Rev. Richard P. Camp
Van Riper Ellis Church

ADDRESS ... Rabbi Ahron Opher
Barnert Memorial Temple

PRESENTATION OF MEMORIAL PLAZA Miss Eleanor Tomb
United Organizations

UNVEILING OF ENTRANCE PLAQUES

PRESENTATION OF PARK FACILITIES Mr. Fred Fox
Memorial Park Civic Group

ACCEPTANCE ... Hon. John K. Pollitt
Mayor

— CUTTING OF RIBBON BY SILVER JUBILEE QUEEN —
Miss Lorraine Robertson

ADDRESS Rev. Anthony J. O'Driscoll, O.F.M.
St. Anne's R. C. Church

THE FUTURE OF MEMORIAL PARK Mr. Monteford Weed
Recreation Director

PRINCIPAL ADDRESS ... Mr. Chris Edell
National Commander, Legion of Valor

PRESENTATION OF FLAG .. Mr. Morris Dobrin
Rotary Club

FLAG RAISING ... Youth Representatives

— MEMORIAL SERVICES —
By American Legion, Catholic War Veterans, Veterans of Foreign Wars

BENEDICTION ... Rev. Egbert J. Dunker
Our Savior Lutheran Church

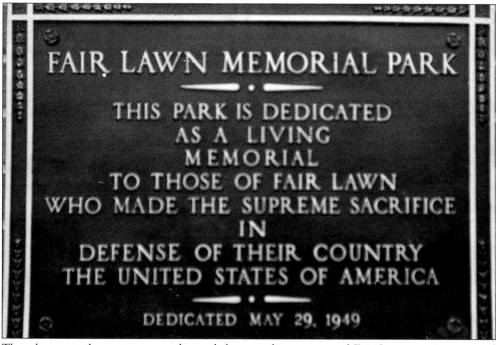

The plaque at the entrance to the park honors the memory of Fair Lawn servicemen and servicewomen who gave their lives in the defense of their country. Each year, the Memorial Day parade ends at this site with a tribute by residents of Fair Lawn to its fallen heroes.

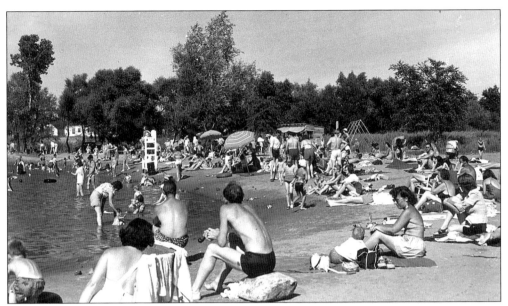

The enormously popular Memorial Pool has welcomed individuals and families on warm summer days since 1949. The park has playground equipment, barbecues, sandy beach, walking paths, and tree-shaded areas to enjoy a stroll.

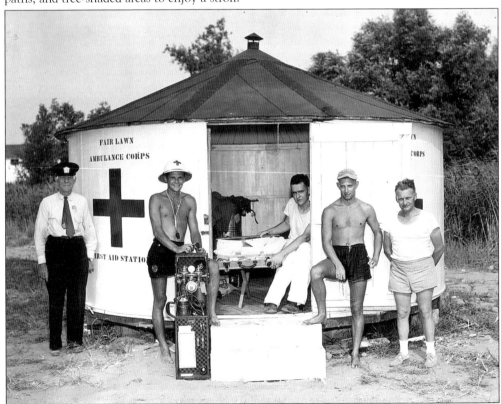

Safety was always an overriding consideration at the pool. The members of the first-aid station were ready for any medical emergency that arose.

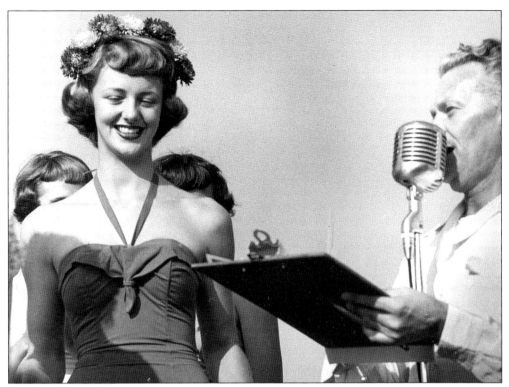

A highlight of the summer recreation program was the Aquacade, culminated by the beauty contest. Starting in 1950, a Miss Fair Lawn was selected from among a bevy of beautiful contestants. The 1950 winner, being presented with the award by Monte Weed, is Carol Paradis. All 13 contestants that year are shown in the lower photograph, sitting on the Memorial Pool diving board. They all deserved to win!

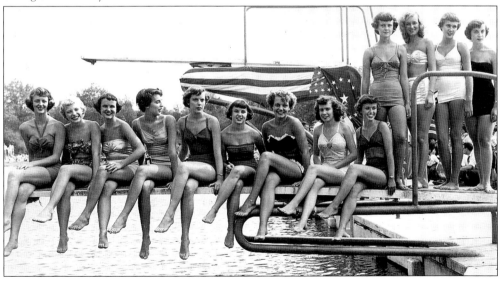

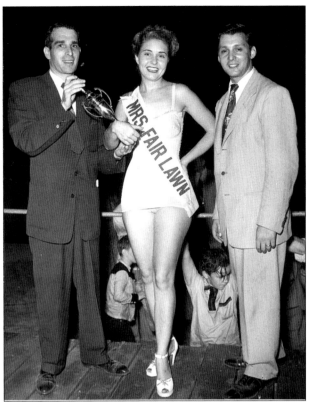

The only Mrs. Fair Lawn ever, Mrs. Thomas Saunders, flashing a beautiful smile, stands between Seymour Cohen and Jess Weston. The beauty pageant was discontinued in 1962, to be replaced by a more politically correct talent contest.

Two little boys are very curious about something on the apron of the Memorial Pool bathhouse. The borough replaced this bathhouse with a more up-to-date structure in 2000.

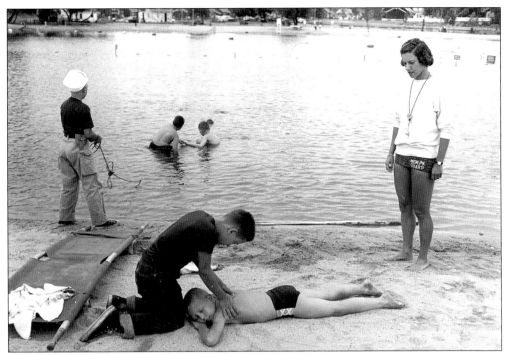

Lifeguard training and certification is offered at Memorial Pool. A student is being supervised as he revives a "victim" of drowning at Memorial Pool in 1957.

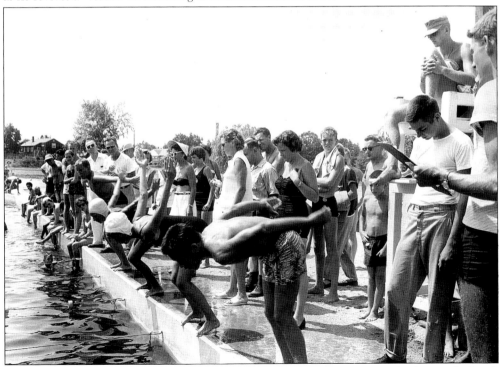

This 1955 swim meet with the Glen Rock team took place under the watchful eyes of officials and supporters.

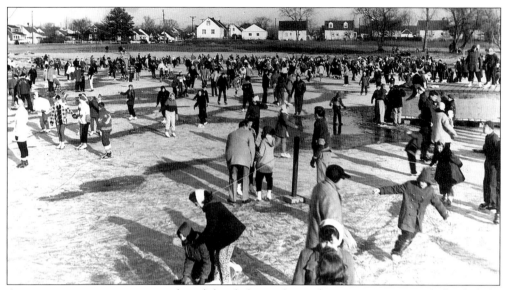

A two-acre area was excavated and leveled out for parking in summer and flooded for ice-skating in winter. All the materials and labor were donated; the cost for constructing the skating area was $2,900.

Supervised ice-skating and an ice-skating show at Memorial Park were part of the winter program in the 1950s. Here, a Fair Lawn couple, identified as Mr. and Mrs. Lou Fertel, participate in the ice show of 1955.

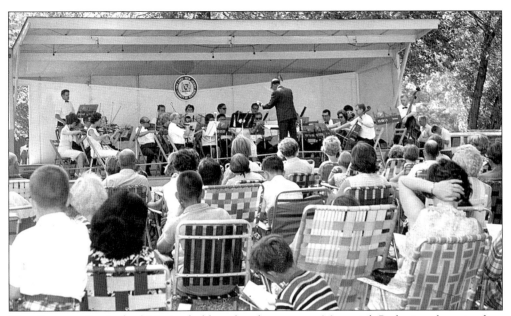

The Summer Festival of Music, held under the stars at Memorial Park, is a longstanding tradition. It is funded by grants, in cooperation with the local chapter of the American Federation of Musicians as well as by individuals, businesses, and civic groups. The 10 concerts held each summer range from jazz to symphonic to big band to country and western.

The driving force behind music in Fair Lawn has been Isadore Freeman, shown here on the lower left. He organized the Summer Festival of Music as well as concerts in the Maurice Pine Public Library throughout the year. Freeman is a professional pianist as well as a piano teacher.

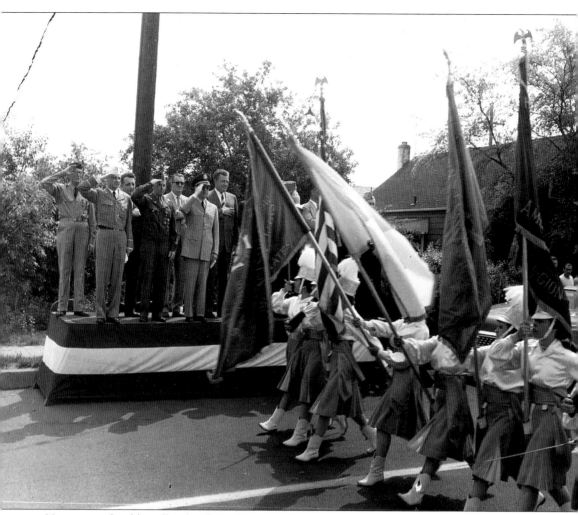

Veterans and public officials salute the color guard at the 1961 Memorial Day parade as they proceed up the Avenue of Heroes at Memorial Park. Mayor Richard Vander Plaat is on the right. James Kimple, superintendent of schools, is third from the left.

Five

GROWTH OF A
MODERN SUBURB

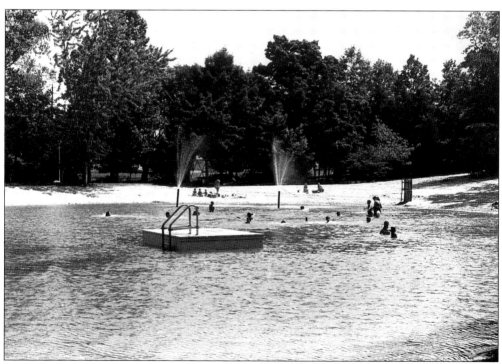

Snyder's Pond was a natural spring that emptied into Bass Lake. Helda Walsh convinced the borough to allow neighborhood residents to construct a park and pool for the neighborhood on that site. With funds raised from a prospective membership, they got the job done. Helda Walsh Pool, as it is known, was returned to the borough as a public pool in the 1980s.

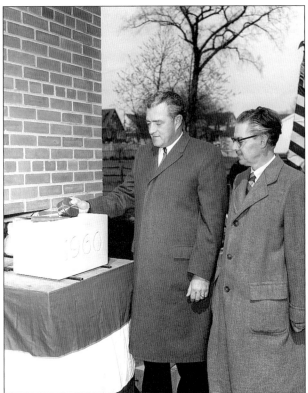

Mayor Richard Vander Plaat places a time capsule in the cornerstone of the new borough hall on Fair Lawn Avenue in 1960. The seat of local government, court, and police department, it is on the site of the old Acker Estate. The need for services grew as Fair Lawn's population surged during the 1950s, requiring the borough to build larger quarters.

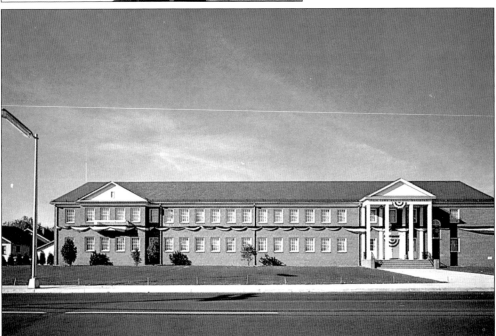

The current municipal building, erected and dedicated in 1960, replaced the one on Gardiner Road that had been part of the Acker Estate. It has since been renovated and made accessible for the handicapped.

An honor roll, a tribute listing the residents of Fair Lawn who lost their lives in war, stands on the front lawn of the Fair Lawn Municipal Building.

Despite its stately façade, nobody seems to enter the municipal building through its front door. Everyone uses the new side entrance, shown in this photograph. The new entrance, an elevator, and ramp were part of the renovations to the municipal building making it handicapped accessible.

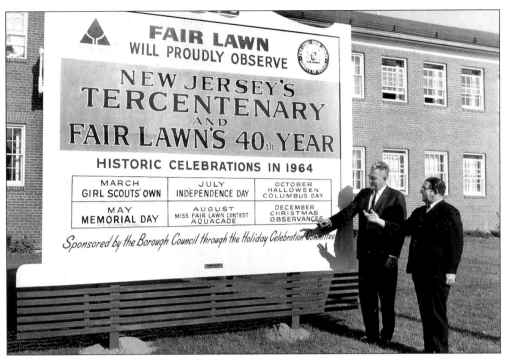

New Jersey's tercentenary coincided with Fair Lawn's 40th anniversary. Observances were held throughout the year. Seen in this 1964 photograph are Mayor Richard Vander Plaat and John Gottlieb.

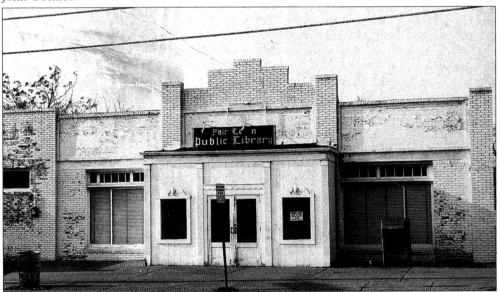

The old public library was constructed in 1951. However, the first library in Fair Lawn was established by Dr. Maurice Pine in a one-room office adjacent to his practice in the Wyder Building on River Road. The library was later relocated to the municipal building on Eleventh Street and, finally, to this structure. The old public library is now the Old Library Theater. Amateur theater groups give performances and many borough clubs meet in the Old Library Theater.

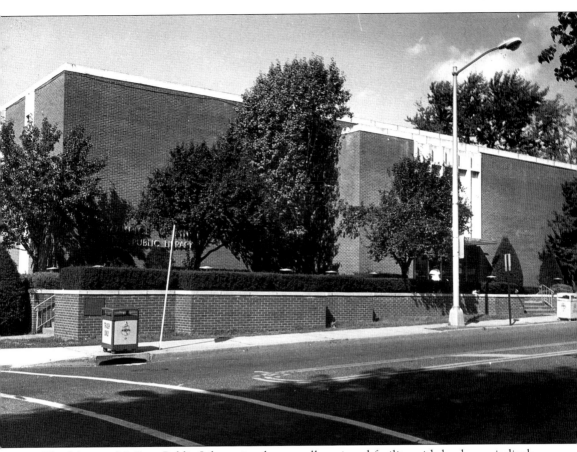

The Maurice M. Pine Public Library is a large, well-equipped facility with books, periodicals, videos, CDs, tapes, and other media in its collection. The building was erected in 1967 on Fair Lawn Avenue across from the municipal building. Patrons borrowed more than 400,000 items in 1999. The library is part of a consortium of 70 libraries called the Bergen County Cooperative Library System, which listed more than 4 million items and circulated 6.5 million items in 1999.

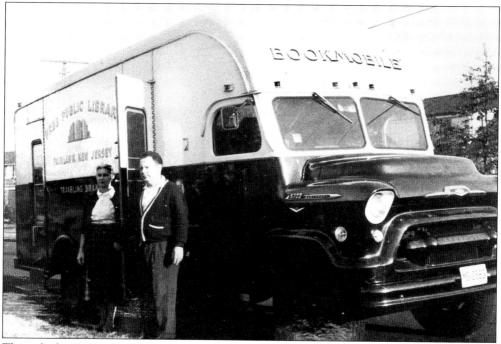

Through the 1970s, the Fair Lawn Public Library operated a bookmobile that made regularly scheduled stops at many locations. The bus would park for a few hours at each one so that library cardholders could borrow and return books. Hazel McCurdy, wife of Postmaster Cameron McCurdy, was the bookmobile librarian.

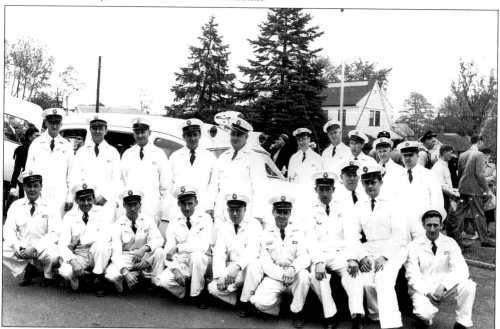

These early volunteer ambulance corpsmen earned their American Red Cross Standard and Advanced Aid Cards as well as instruction in cardiopulmonary resuscitation and obstetrics. They are seen here assembled in front of one of their two Cadillac ambulances.

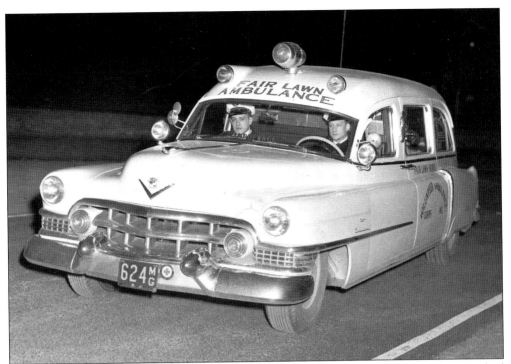

The Fair Lawn Volunteer Ambulance corps was established in 1948. It originally had one ambulance and 20 members trained in first aid. The 1951 Cadillac ambulance was the standard of the day. When not in use, it was housed in a shed behind the old borough hall on Gardiner Road.

Certified emergency medical technicians staff today's volunteer ambulance corps. The 45-member corps responds to 2,000 calls each year. The corps has had its own building on Berdan Avenue since 1953, housing three modern ambulances that are on call day and night. It offers first-aid and CPR classes to residents as well as in-service training for volunteers.

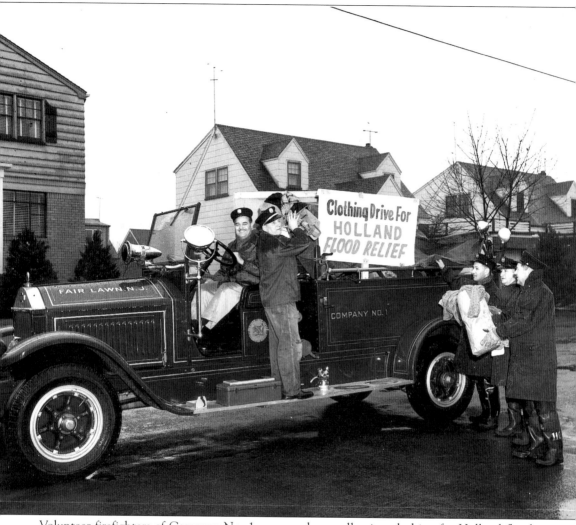

Volunteer firefighters of Company No. 1 are seen here collecting clothing for Holland flood relief in the 1940s. Helping those in need has always been a part of the ethos of the volunteer fire department.

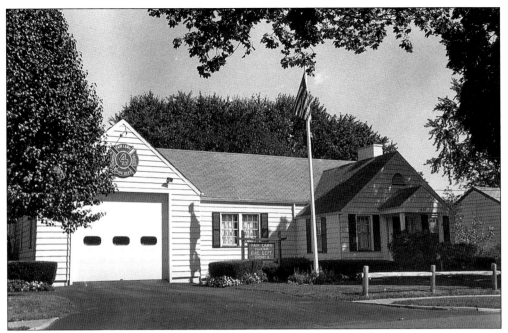

Fire Company No. 4, on Radburn Road, is one of the four volunteer fire companies. Each company elects its own captain. The town fire chief is elected annually by the total membership of all volunteer firefighters. The borough purchases the equipment, and contributions are raised for upkeep of each firehouse.

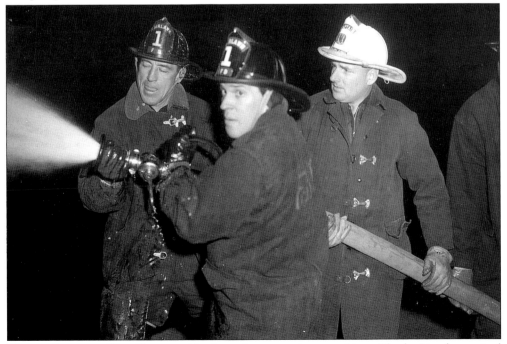

Three volunteers of Fire Company No. 1 are shown putting out a blaze. Charles Vogel organized the first fire company in 1911 even before Fair Lawn became an incorporated borough. There are now four fire companies in town with more than 100 active volunteers.

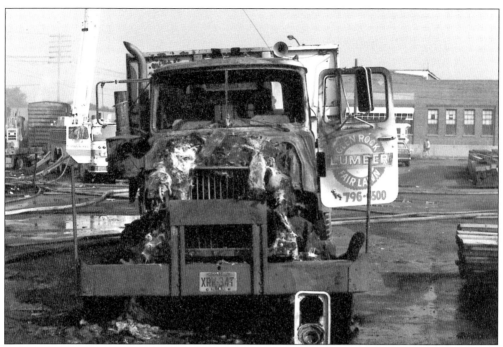

In August 1979, an intense fire broke out at Glen Rock Lumber's depot on Banta Place, threatening to consume adjacent houses. All four of Fair Lawn's fire companies responded, as well as those of nearby Paramus, Elmwood Park, Glen Rock, and Saddle Brook. In all, about 100 firefighters worked to put out the fire. The fire, fed by the lumber, was so intense it charred the lumber truck seen here. Fire Company No. 1's snorkel truck was used to extinguish all the smoldering embers.

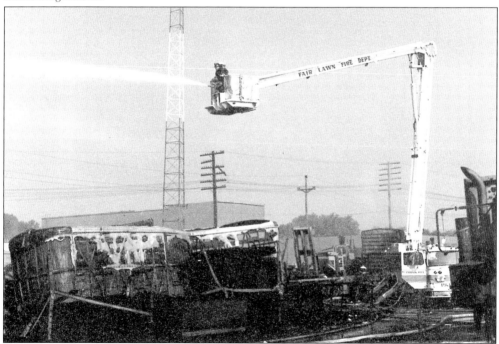

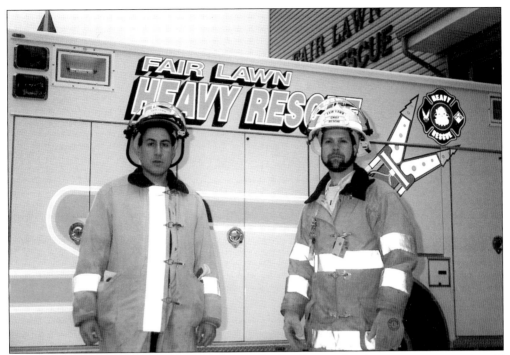

The Fair Lawn Heavy Rescue Squad, composed of well-trained volunteers, comes to the aid of trapped and injured people. This organization also includes haz-mat (hazardous materials) volunteers who are prepared to deal with spills of chemical or toxic materials. Their gear is contained in specially outfitted trucks that can deal with any emergency.

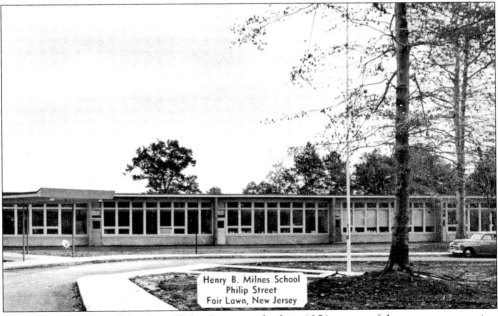

Henry B. Milnes School
Philip Street
Fair Lawn, New Jersey

The Henry B. Milnes School on Philip Street was built in 1951 as part of the postwar expansion of the borough. It is named for "Pop" Milnes, who was founder of the Fair Lawn Boys Club and an important community leader.

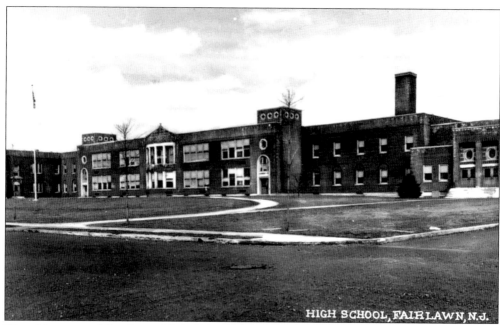

The oldest part of Fair Lawn High School, seen here, was built in 1943 on Burbank Street. Before that time, children attended high school in Ridgewood, Paterson, and Hawthorne.

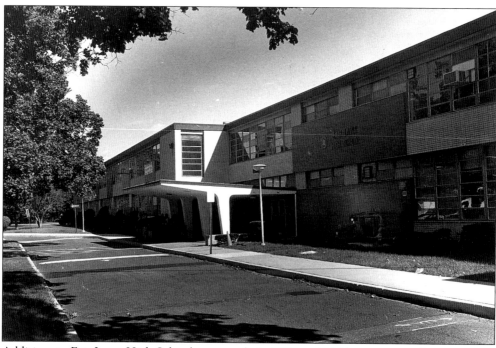

Additions to Fair Lawn High School were made in 1957 and 1964 to accommodate a growing student population and increasing needs of the curriculum. Currently, 1,400 students in grades 9 through 12 attend the high school. The additions to the original red brick building are shown in this photograph.

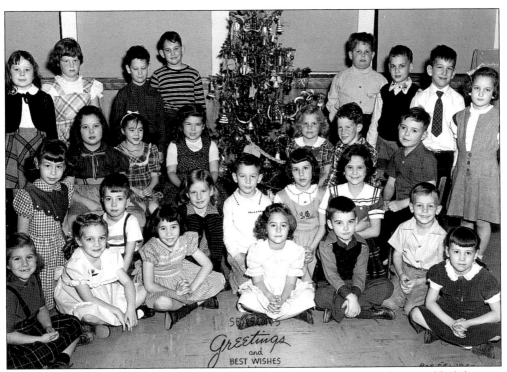

Mrs. Feldman's first-grade class in Lyncrest School poses in front of their decorated holiday tree in 1951. Mrs. Feldman appears to be absent from the photograph.

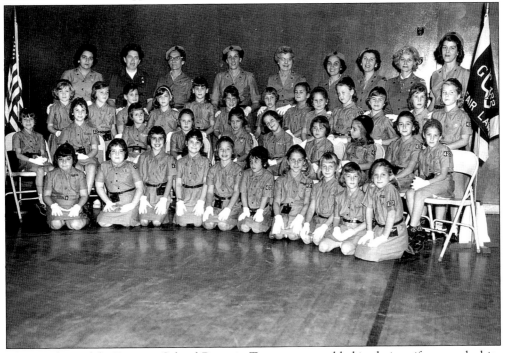

The members of the Lyncrest School Brownie Troop are assembled in their uniforms and white gloves for their group picture in 1963.

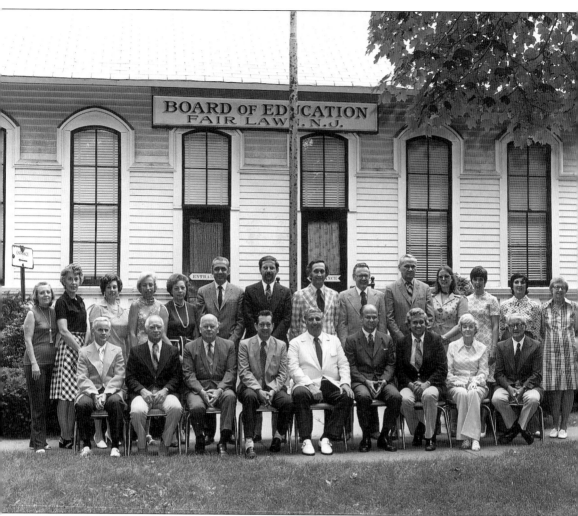

The board of education administrative staff is seen here in the 1970s in front of the Washington School, which had been converted to their administrative offices. They are, from left to right, as follows: (front row) Robert Whitehead, business assistant; Arthur Brotherton, supervisor of buildings and grounds; Charles Lyons, principal of Lyncrest School; Joseph Ubelhart, director of elementary education; Thomas Cannito, superintendent of education; Daniel Rothermel; Frank Montalbano, principal of Memorial Junior High School; Ruth Lill, principal of Radburn School; and Floyd Smith, principal of Edison School; (back row) Henrietta Larkin, payroll clerk; Eleanor Francis, certification clerk; Gloria Duhl, secretary to director of elementary education; Louise Tanis, substitute clerk; Gladys Glassman, office manager; Paul Christie, assistant supervisor of buildings and grounds; William Rothenberg, principal of Warren Point School; Henry Bernhardt, principal of Forrest School; Eleanor Campbell, principal of Westmorland School; Thomas Szymczak, principal of Milnes School; Christine Muhlenbruch, clerk; Doris Bourhill, accounting assistant; Beatrice Schwartz, secretary; and Claire Gaver, secretary.

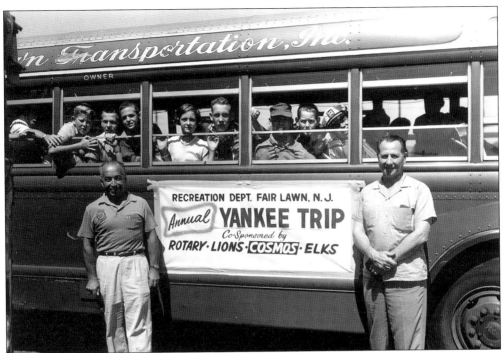

Civic organizations and business have been generous supporters and cosponsors of activities with the recreation department, sponsoring baseball teams and annual trips to Mets and Yankees baseball games. This photograph of a busload of kids going to the Yankees games was taken in the 1960s.

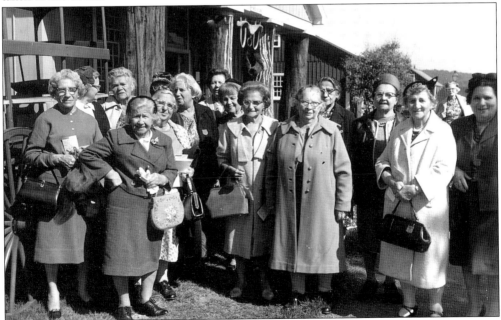

Even before the establishment of the senior citizens center, Fair Lawn provided many activities for its older residents through the recreation department. Senior citizens were taken on trips by bus. This photograph of sophisticated tourists dates from 1964.

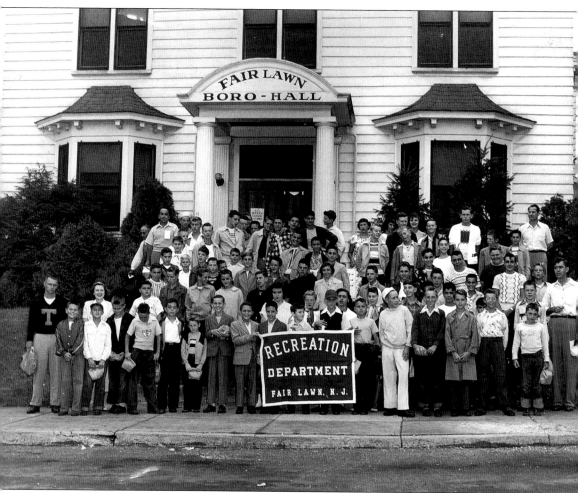

From its founding, Fair Lawn has been a community that has supported activities for all age groups. This is a 1950s photograph of the Playground League, the forerunner of the parks and recreation summer program. Monte Weed, director of recreation, is seen on the extreme right in the front row. Virgil Sasso, a high school physical education teacher, is in the back row on the right.

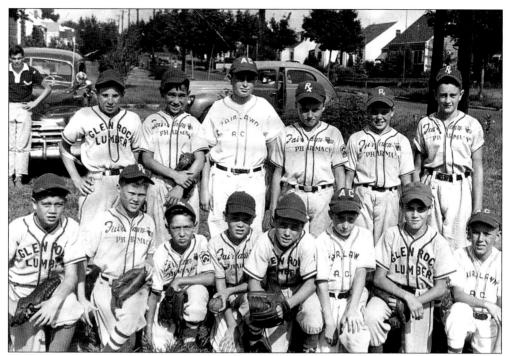

Little League started in 1951 with four teams participating. The Little League All-Stars team of 1952 had members from the teams sponsored by Fair Lawn Pharmacy, the Fair Lawn Athletic Club, and Glen Rock Lumber.

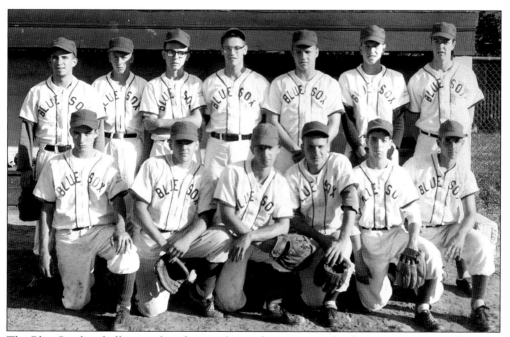

The Blue Sox baseball team played teams from other towns under the auspices of the All-Sports Association, an independent organization working in cooperation with the recreation department. This is their 1962 team picture.

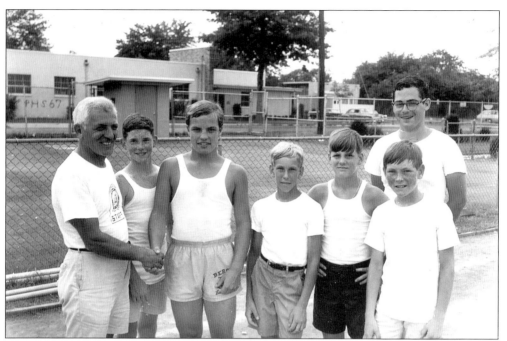

Martino of the recreation department summer staff poses with members of the Fair Lawn Junior Olympics team. Pictured are, from left to right, Martino, Mike Ivory, Billy Lee, John Perkins, Brian Sullivan, and Joe Wichnicki. Fred Franks is in the rear on the right.

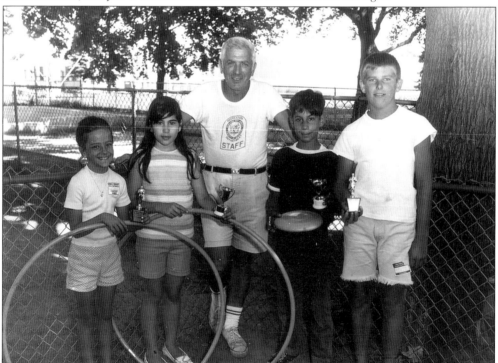

Martino is shown here in 1968 with the winners of the hula-hoop and Frisbee competitions. The extensive summer program had an activity for every interested child.

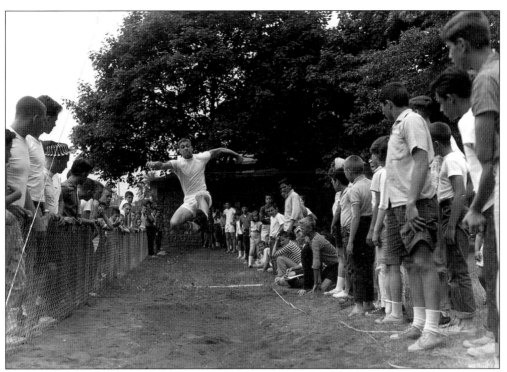

Carl Richard seems to be suspended in midair during his 1961 championship long jump. This was just one of the many athletic competitions held each summer.

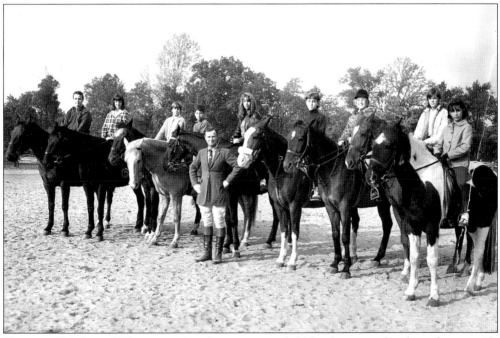

Horses in Fair Lawn? The recreation department took kids who wanted to learn how to ride to the Allendale Riding School. This 1966 photograph shows the children with their riding instructor. The small "riding academy" behind the Grange Hall was defunct by this time.

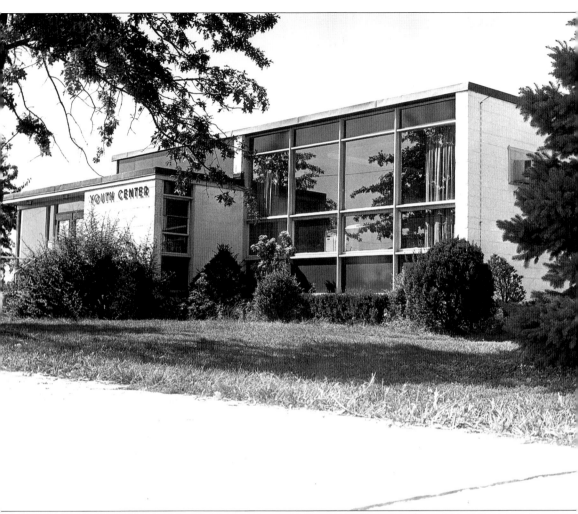

Fair Lawn's award-winning recreation department runs programs throughout the year for children and youths. The youth center was built in 1956 on Twentieth and Kipp Streets. It operates programs for boys and girls from grades 5 to 12 between September and April, offering indoor sports, games, television, video, movies, and dances.

Halloween brings out the costumed children for the annual Halloween Costume Parade, sponsored by the recreation department. Led by a police car and a banjo band, the children parade around the Memorial Park. Sponsors serve doughnuts and cider, and each child receives a treat bag filled with goodies.

Before the cellular phone and the Internet, young people would communicate by ham radio with people all over the world. This 1967 photograph shows two members of the radio club, which was sponsored by the recreation department, and their instructor.

This ham radio operator QSL card of Gary Alpart dates from the 1950s.

The recreation department sponsors any activity if there is an interest in it. Members of the 1963 Flying Club, James Inzalaco and Greg Lutz, are getting ready to fly their model airplane.

An a cappella singing group, the Sweet Adelines, was sponsored by the recreation department. They are seen here in 1966.

Artists and potential artists abound in Fair Lawn. This art class, held in June 1949, was sponsored by the recreation department. The teachers standing near the window are Q.B. Leone and Pam Young.

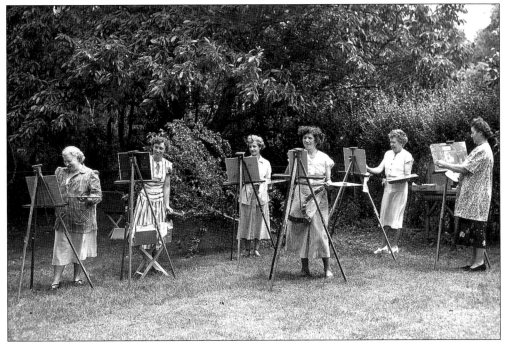

Some smiling, some grimacing, these women try to capture the beauty of the landscape in front of them. Painting from nature was part of the 1950 summer recreation department program.

In this 1966 photograph, a very expressive sculpture teacher is demonstrating how to a model a head in clay. The Arts Association sponsored the class.

The Arts Association is the umbrella organization that sponsors classes in painting, drawing, and sculpture in the Old Library Theater for all ages and holds exhibitions of student work. The top photograph captures some of the entries in the 1968 adult exhibition. Pam Young has taught countless Fair Lawn artists. She is seen below (back row, second from left) at a 1964 outdoor art show sponsored by the Arts Association.

L. Barry Tedesco played a major role in music education and performance. He was the high school music teacher for many years, as well as the leader of the marching band and director of Fair Lawn's Choral Society. The choral society, founded in 1946, is seen here in 1950. They are, from left to right, as follows: (first row) Mrs. M. McClellan, P. Cassidy, M. Hamilton, E. Crutch, D. Chapman, L. Barry Tedesco, G.A. Kelly, accompanist, Mrs. J. Vanderwende, J. Stroud, A. Slicher, Mrs. E. Seidel, and R. Hugenschmidt; (second row) Mrs. E. Haug, Mrs. E. Milnes, E. Davis, L. Bahoosh, O. Grozdic, V. Hedman, A. Storer, M. Cazin, R. Eliezer, J. Eberhardt, I. DeWilde, and R. Walter; (third row) E. Nest, Mrs. B. Long, B. Jones, Mrs. A.C. Diepeveen, J. Gennaro, P. Muoy, H. Jacksewicz, D. Hale, Mrs. L.B. Tedesco, M. Miller, P. Roughgarden, and M. Walter; (fourth row) J. Vanderwende, J.G. Corson, C. Bryson, W. Davis, G. Hale, J. Van Allen, G. Stamp, B. Mohring, H. Yerger, G. Lamberson, Mrs. M. Lamberson, Mrs. D. Weed, and Mrs R. Boyce.

The nutrition center at the Warren Point Presbyterian Church was the forerunner of the senior citizens center. The first director, Goldie Singer (extreme left), became the director of the senior citizens center when it opened in May 1980. Gov. Brendan Byrne visited the nutrition center on October 26, 1978.

Children in 4-H raised animals and crops for the 50th Anniversary Farm on Frank McBride's land at Route 208 and Fair Lawn Avenue. Boy Scout Troop 240 and 4-H held a fair that included a contest for the most congenial animal. The pig was raised on the farm and the goat belonged to Dr. Albert Rosen, a pediatrician. Seen here, from left to right, are Peter Mancini, John Gottlieb, Dr. Rosen, and David Horowitz.

The Fair Lawn Borough Council poses in 1974 for the official 50th anniversary photograph. They are, from left to right, as follows: (front row, sitting) Mayor Robert Landzettel; (back row, standing) John Cosgrove, Nat Sprechman, Meyer Sugarman (borough attorney), Donald DeBruin (municipal clerk), Nicholas Felice, George Pellack (manager), and Andrew Fox.

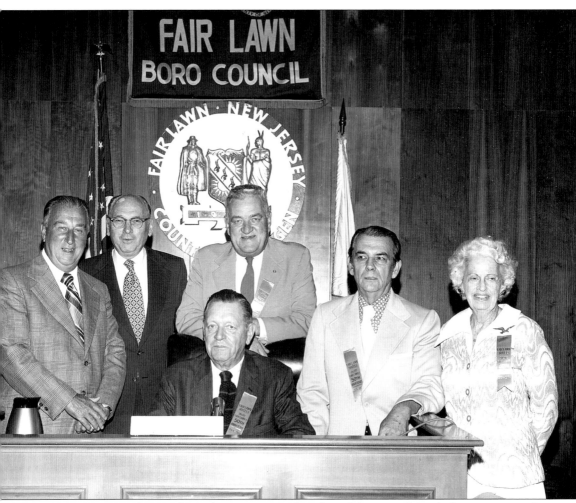

Former mayors and council members participated in the celebration of the 50th anniversary of Fair Lawn. Pictured, from left to right, are the following: (front row, sitting) former Mayor John K. Pollitt; (back row, standing) former Mayor Paul W. Hardy, Rev. Richard Camp (of the Van Riper-Ellis Memorial Baptist Church), former Mayor Richard Vander Plaat, former Mayor Gus Rys, and former council member Kay L. Lyle.

Marching bands, cars, and floats paraded in celebration of Fair Lawn's 50th anniversary in 1974. The Fair Lawn Democratic leaders are riding in an open top car. They are, from left to right, Irving Bienstock, Louis Raffiani, Bernard Hersh, Florence "Flossie" Dobrow, and Dr. Henry Shapiro.

An antique wooden car carrying representatives of the Fair Lawn Republicans took part in the 50th anniversary parade. Council member John Cosgrove, wearing straw boater, and his wife, Ann, are being driven by "Butch" Krauss.

Members of the borough council of 1990 are riding in the traditional Memorial Day parade. They are, from left to right, Mary Burdick, John Keith, Florence (Flossie) Dobrow, Robert Gordon, and Stanley Nerenberg. Mrs. Dobrow, the longest serving member of any municipal governing body in New Jersey, was often seen riding her tricycle around town, and this occasion was no different.

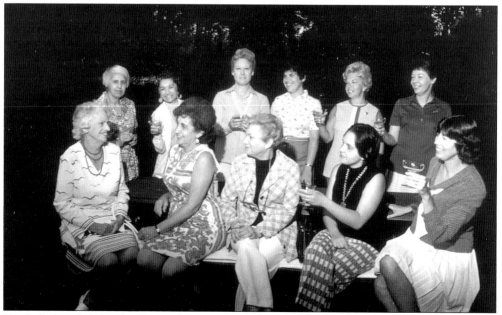

Kay Lyle founded the Fair Lawn chapter of the League of Women Voters in 1937. At the 25th anniversary of its founding, the board members saluted her with champagne, as shown in this 1962 photograph. They are, from left to right, as follows: (front row) Kay Lyle, Diane Blumberg, Mary Burdick, Pearl Weiss, and Jane Lyle Diepeveen; (back row) Adele Dresner, Frances Davis, Gloria Korn, unidentified, Martha Buchsbaum, and Vera Klueger.

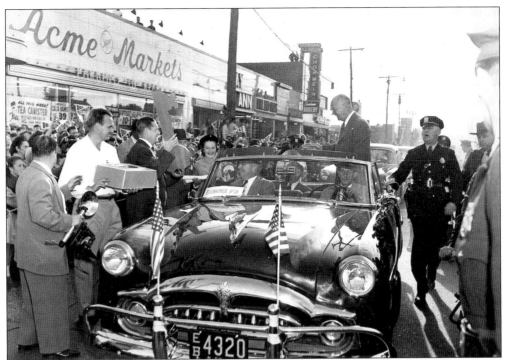

Gen. Dwight D. Eisenhower came to Fair Lawn during his 1952 campaign. Seen here riding down Broadway in a convertible, he is flanked by police officer Robert Grunstra. The photographer on the left is Russ Zito, who did much of Fair Lawn's official photography.

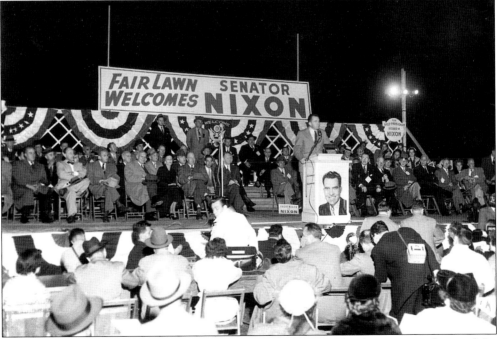

In 1952, Sen. Richard Nixon came to Fair Lawn to campaign for the vice presidency of the United States. Ultimately, he and Eisenhower prevailed in that election.

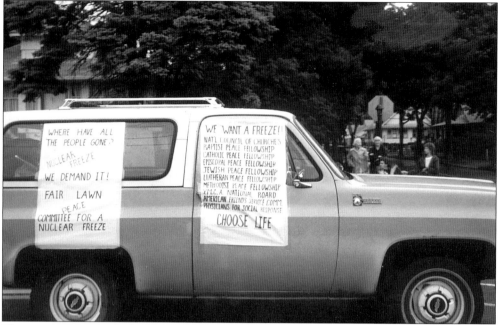

This station wagon was driven in the Memorial Day parade at the height of the nuclear freeze movement of the early 1960s. It carried signs indicating support by 10 peace organizations, including Fair Lawn's Peace Committee for a Nuclear Freeze.

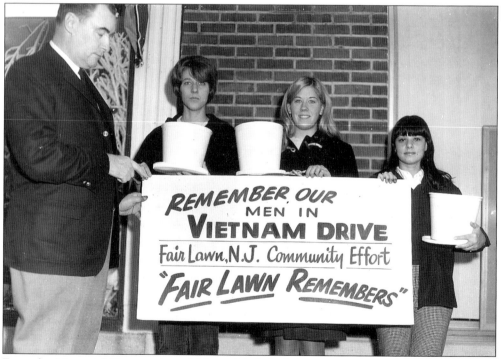

From the Memorial Day parade and Memorial Park dedication to this 1966 remembrance of Vietnam service members, Fair Lawnites have always paid tribute to past and current members of the armed forces.

Dr. Benjamin Spock came to Fair Lawn to speak at an antiwar rally at the height of the Vietnam War in 1968. The rally took place at the Thomas Jefferson Middle School.

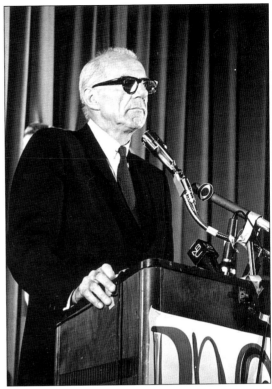

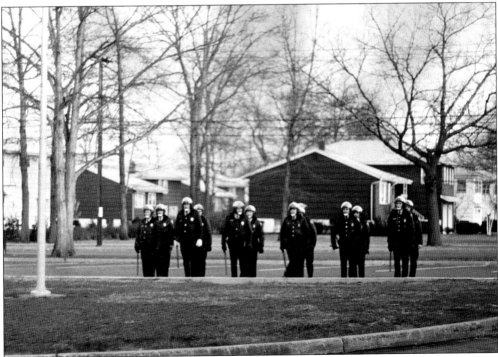

Police were out in force in their riot gear to prevent clashes between groups holding opposing viewpoints on the Vietnam War.

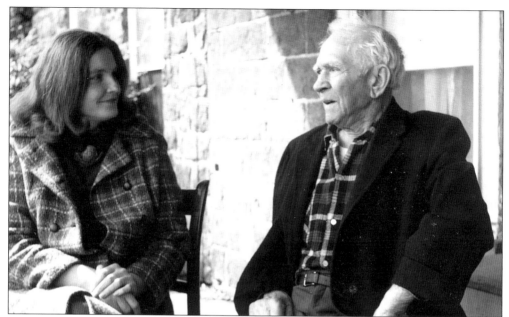

Feenix Brocker, the last family member to own the Garretson-Brocker Homestead, is shown here with Lois Horowitz in a 1974 photograph. Mrs. Horowitz was discussing the possible use of the Garretson Farm by the 4-H club. This event marked the beginning of the campaign to acquire and preserve the historic property.

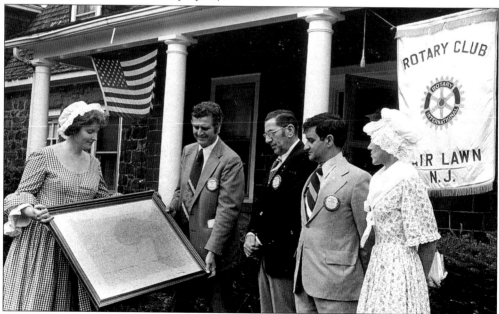

In 1708, King George awarded an indenture or deed for a large parcel of land on which the Garretson-Brocker House stands to Daniel Danielson and 11 other Quakers. The Garretsons of Slooterdam purchased it from them in 1719. Lois Horowitz shows the original indenture to members of Fair Lawn Rotary who met on October 16, 1975, at the Garretson Forge and Farm. They are, from left to right, Lois Horowitz, then president of the Garretson Forge and Farm; Dante Lozzi; George Kirsch; John Nakashian; and a Garretson Forge docent.

Lois Horowitz, seen here in black dress, spearheaded the movement to restore the Garretson Forge and Farm (Garretson-Brocker Homestead), which had been acquired through grants and fundraising. The driver of this float in Fair Lawn's Memorial Day parade is John O'Neill, a member of the Garretson Forge.

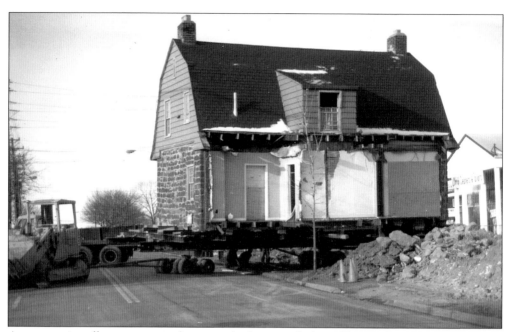

A community effort was required to save the historic Cadmus House when it was threatened with demolition. The solution was to move it from its location on Fair Lawn Avenue to property adjacent to the Radburn Railroad Station. The house had to be removed from its foundation, loaded onto a special flatbed truck, and driven a few hundred yards to its new location. It was attached to a new foundation and all the electrical and water connections were made. These photographs show the progress of the move as the house was towed down Fair Lawn Avenue. Truly, history was on the move!

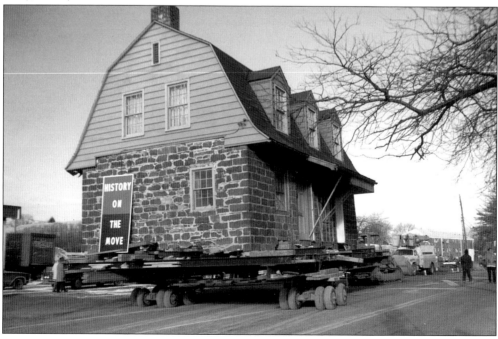

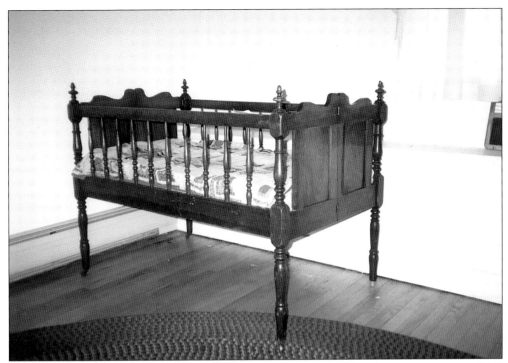

Furnishings and historical artifacts that document the history of Fair Lawn are now assembled in the Cadmus House, which houses the Fair Lawn Museum. Thomas W. Lewis, grandfather of Fair Lawn's borough historian Jane Diepeveen, used this mid-19th-century crib. An ice chest and a plow are just a few of the artifacts that are in the Fair Lawn Museum.

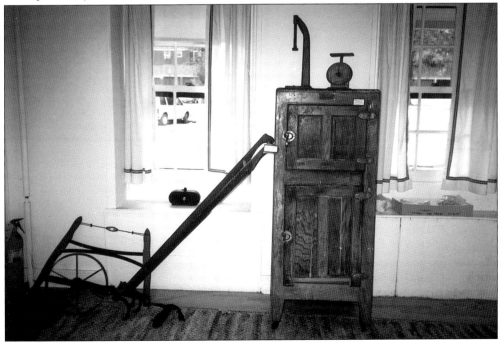

Former fire chief John Cosgrove Jr. is seen here showing a document to a visitor in the Firemen's Room at the Cadmus House. One room on the second floor of the house displays photographs, news clippings, and equipment used by the early fire department.

Superintendent of recreation Monteford (Monte) Weed is seen in this image unveiling a portrait of municipal judge Morris Dobrin in 1968. Dobrin, as a Fair Lawn attorney, spearheaded the fund drive for construction of Memorial Park and worked on behalf of the borough's recreation program for many years.

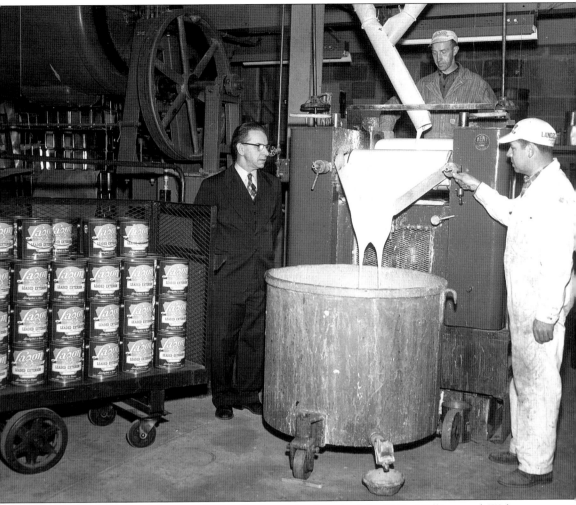

The grand opening of the new Lazon Paints took place in July 1949. William and Walter Landzettel, sons of the founder, are seen supervising paint production in the new factory.

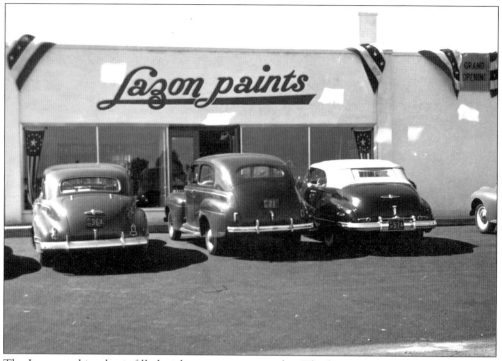

The Lazon parking lot is filled with cars on opening day. The business is now run, at the same site, by the third generation of Landzettels—Robert, Donald, and Walter Jr.

Depending on the direction of the wind, you can often smell the cookies being baked at the Nabisco factory, the largest manufacturing establishment in the Fair Lawn Industrial Park. Its tower, the tallest structure in Fair Lawn, is visible from a great distance. Nabisco bakes its world-famous Oreo cookies here.

The oldest business in Fair Lawn is Kuiken Brothers Lumber, founded by Richard, Henry, and Nicholas Kuiken on Sixth Street in 1912. Originally a general contracting business, responsible for construction of many homes in Fair Lawn, it evolved into a lumber and hardware company. Ken and Doug Kuiken, seen in this photograph, now run the business.

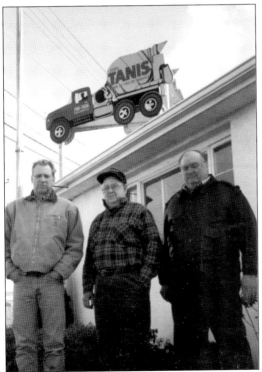

Just down the street from Lazon Paints is Joel Tanis & Sons Ready Mixed Concrete, another business run by the family's third generation. Although they purchased the first cement-mixing truck in 1939, the Tanis trucks are now a familiar sight on the roads. Charles Tanis (center), son of founder, and his sons Mark and Wayne run the business today.

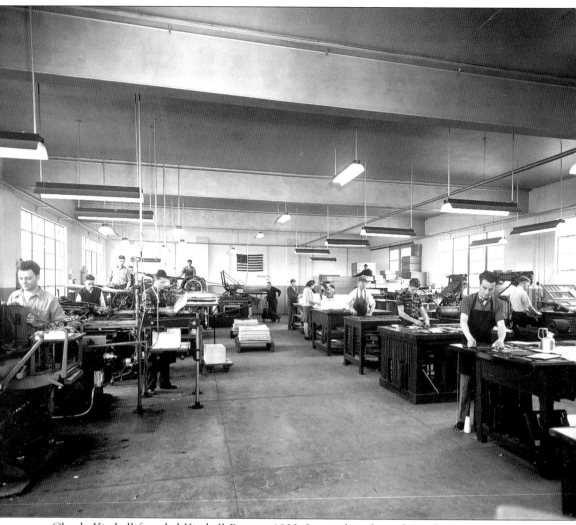

Claude Kimball founded Kimball Press *c*. 1900. Located in the industrial area at Banta Place and Raphael Street, it was a full-service printing company that produced books and magazines as well as stationery for many years. This 1950 photograph shows the workings of the press.

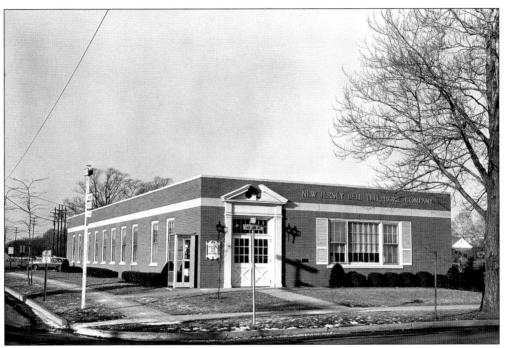

The New Jersey Bell Telephone Company building, at Fair Lawn Avenue and Pollitt Drive, was converted to medical offices when that telephone company became part of Bell Atlantic.

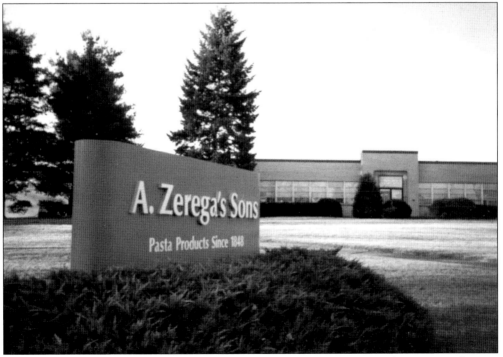

A. Zerega's Sons established a modern factory on Broadway in the 1950s where it manufactures the Columbia Spaghetti and Noodle brand of pasta. It is still doing business at that location today.

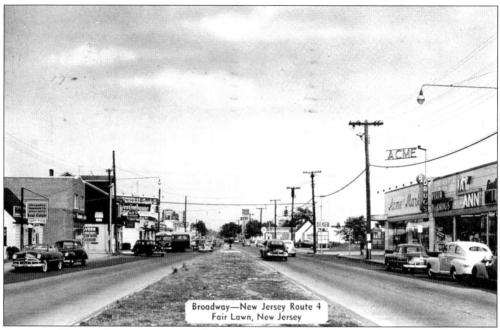

Broadway—New Jersey Route 4
Fair Lawn, New Jersey

Broadway (Route 4) was a main road through the Warren Point section and went all the way to Paterson. It was a major shopping center during the 1950s, having as many as three supermarkets at one time (Acme, A & P, and Food Fair). These views of Broadway look east. The upper photograph shows the scene at the junction of Plaza Road; the lower photograph is the view from Midland Avenue.

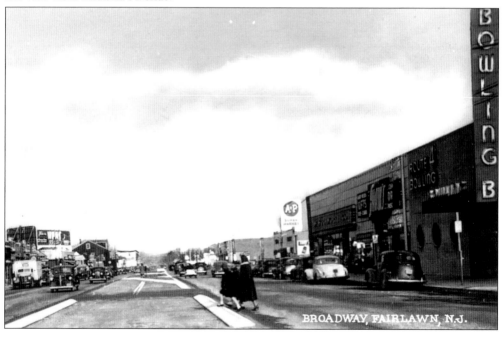

BROADWAY, FAIRLAWN, N.J.

Jahn's Coffee Shop stood at the Route 4 entrance to Fair Lawn at Route 208. It was known for its extraordinary ice-cream sundae and soda creations. Some of the sundaes (especially one called the Kitchen Sink) required an entire family to consume. The River Palm Restaurant now occupies the site.

One of the more colorful stores along Broadway was the Turqouis Indian. Guarded by two large wooden Indians, it sold a variety of American Indian arts and crafts.

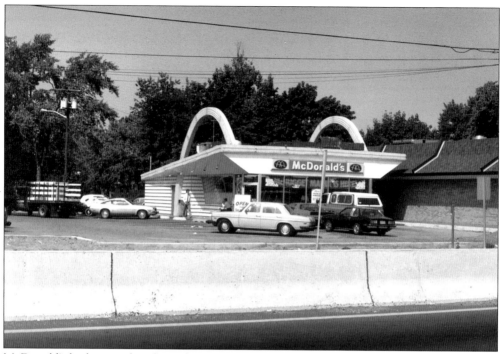

McDonald's built one of its first take-out restaurants on Broadway in Fair Lawn. Seen in this 1983 photograph, it had a red-and-white tile front and proudly displayed the golden arches. It originally had a billboard that indicated how many burgers had been sold nationwide. In the 1980s, the newer style McDonald's restaurant replaced it.

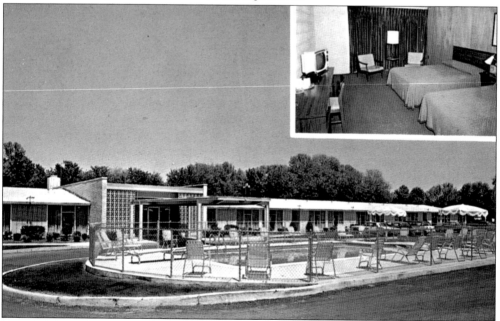

Fair Lawn's land use regulations do not allow for hotels or motels to be built in any zone. However, this was not the case when the Suburban Motor Hotel was built in the 1950s. The Amerisuites Hotel replaced it in the 1990s.

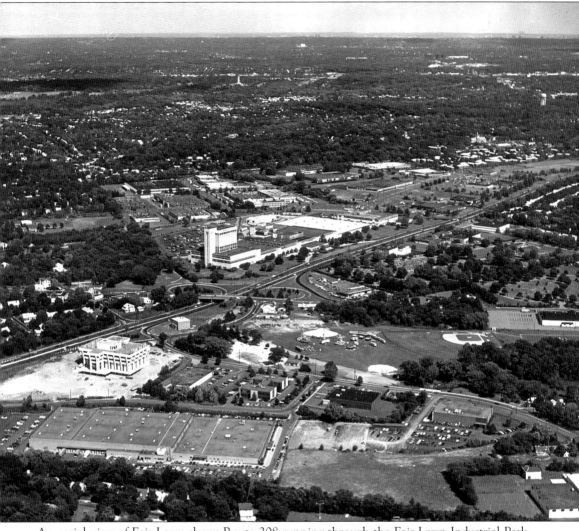

An aerial view of Fair Lawn shows Route 208 running through the Fair Lawn Industrial Park, developed by Frank McBride. This 173-acre site was one of the first industrial campuses designed with esthetics in mind to fit into a suburban community. The Nabisco Company, which baked cookies here, can be identified by its landmark tower; it is the tallest structure in Fair Lawn. Other early corporate occupants were Kodak, Lea & Perrins, Oxford University Press, Sandvik Steel, and Coats & Clark. Rental apartments built in 2000 now occupy the open land, at the junction of Route 208 and Fair Lawn Avenue, on which corn was once planted every year.

Interstate Boochever Corporation, located in the Fair Lawn Industrial Park on Pollitt Drive, manufactured product displays. These old postcards advertise the displays they manufactured for Pillsbury and Cheeseborough Ponds.

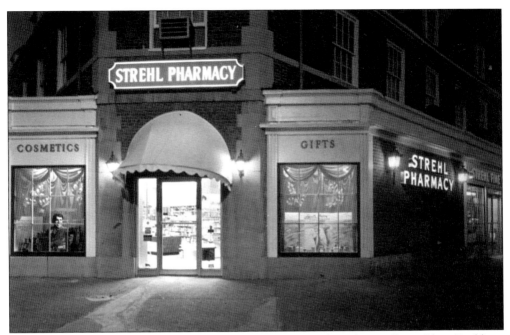

Henry Strehl founded Strehl's Pharmacy in 1929. Located in the Radburn Plaza Building, it offered prescriptions drugs and patent medicines, gifts, candy, and cosmetics. A liquor department was added after the repeal of Prohibition. Patrons could charge their purchases, and Strehl's offered free delivery.

Before the introduction of national pharmacy stores, the neighborhood pharmacist was an important adjunct to the neighborhood physician. Charles Pharmacy on Fair Lawn Avenue was one of several neighborhood pharmacies in Fair Lawn that included Plymouth Park, Strehl's, and Fair Lawn Pharmacy. Charles Pharmacy advertised their establishment on this postcard.

THE WHITE HOUSE

WASHINGTON

October 27, 1999

It is a pleasure to send greetings and
congratulations to all who are celebrating the
75th anniversary of Fair Lawn, New Jersey.

Since its beginnings, your borough
has provided a home for people to raise their
families and develop the strong bonds that define
a community. This anniversary is a testament
to Fair Lawn's appeal to those seeking a welcoming
place with a rich and diverse heritage. Right now,
Americans are embracing a season of renewal, dedi-
cating themselves to improving their communities.
Your celebration presents a wonderful chance to
highlight the achievements of the citizens of
your borough, reflecting on all that has been
accomplished and all that can still be achieved
in the future.

Best wishes for an enjoyable event.

Recognition of the volunteer spirit that has made Fair Lawn a great place to live came from all
quarters during the 75th anniversary celebration. Pres. William J. Clinton sent his best wishes
and congratulations to all on October 27, 1999. A replica of this letter is prominently displayed
in the borough hall.